SPIRITUAL AMERICAN TRASH

SPIRITUAL
AMERICAN TRASH

Portraits from the Margins of Art and Faith

GREG BOTTOMS
Illustrated by W. David Powell

COUNTERPOINT
BERKELEY

Bottoms, Greg.
Spiritual American trash : portraits from the margins of art and faith / Greg Bottoms.
 pages cm
 ISBN 978-1-61902-059-7 (pbk.)
 1. Art, American—20th century. 2. Art, American—21st century.
 3. Outsider art—United States. 4. Spirituality in art. I. Title.
 N6512.5.O87B68 2013
 709.2'273—dc23

Interior design by Sabrina Plomitallo-González, Neuwirth & Associates
Illustrations and Jacket design by W. David Powell

COUNTERPOINT
1919 Fifth Street
Berkeley, CA 94710
www.counterpointpress.com

Distributed by Publishers Group West
Printed in the United States of America

10 9 8 7 6 5 4 3 2 1

TABLE OF CONTENTS

To try to understand the experience of another it is necessary to dismantle the world as seen from one's own place within it, and to reassemble it as seen from his. For example, to understand a given choice another makes, one must face in imagination the lack of choices which may confront and deny him. The well-fed are incapable of understanding the choices of the under-fed. The world has to be dismantled and reassembled in order to be able to grasp, however clumsily, the experience of another. To talk of entering the other's subjectivity is misleading. The subjectivity of another does not simply constitute a different interior attitude to the same exterior facts. The constellation of facts, of which he is the centre, is different.

—John Berger

Art does not lie down on the bed that is made for it; it runs away as soon as one says its name; it loves to go incognito. Its best moments are when it forgets what it is called.

—Jean Dubuffet

SPIRITUAL AMERICAN TRASH

INTRODUCTION

I call this book a collection of "portraits." It is made, in the spirit of the outsider artists I portray, of found materials. My process has been to steep myself in the facts of these artists' lives, which I found in newspapers, documentary films, websites, museum catalogs and brochures, obituaries, and magazine articles (all of which you could find yourself). From these notes I would create a skeleton of biography (sometimes dubious, with facts in different so-called factual records contradicting each other), around which I would write a character sketch focused on the drama of artistic drive and the psychological impulse to create born of suffering, poverty, and social marginalization, all against the backdrop of the United States in the twentieth century. Of course this book is not the stories as the artists themselves would tell them, or as a scholar or art curator or news journalist would tell them, but rather my subjective interpretations and improvisations around the facts. I care about facts—find them fascinating—and I certainly don't have any right to knowingly change the verifiable facts of other people's lives, so I've done my

best to be accurate on that score, understanding that "accurate," over time and through art-world talk, history, and journalism, is far from a solid state (more like gas with the wind blowing). Around these already some-times dubious facts I've been selective in the service of the story *as I see it*, and I've marshaled a lot of fictive forces short of whole-cloth invention—speculation, conjecture, imagining of intentions, entering the points of view and consciousnesses of others, inventing minis-cenes around the known or rumored to narrate rather than report or analyze key moments of change.

When I was younger, I studied drawing and painting, which accounts for part of my interest in outsider art and artists. I was focused, from the start, on realism, even photographic realism (which required the highest level of craft and skill, I believed), and that has carried over to all that I've written, whether autobiographical fiction with one foot in the essay or nonfiction at the very edge of the novel. Over the years I've become increasingly interested in the gray area between fact and fiction, truth and memory, historical records and historical stories, as a space to work as a writer—not to be coy or to try to exploit some potential capital in the "true" or "tragic," but because I am a product of my time and culture (I'm in it; I think about it) and this is the real space in which we all exist, in layers of random information, cursory or even mendacious interpretation, skewed and dangerously clueless ideology, comforting myth that works on the mind the way corn syrup works on the body, and plain fantasy. When I drew

as a kid, I wanted a tree to express the full truth of my perception of that tree, which, when you think about it, was the only truth I had real, honest, unequivocal access to. That is what art has always been to me, an adventure in saying *this is what I see* and *life is like this*.

I quit writing fiction in any conventional sense of the *I'm-making-this-up* a long time ago, partly because to me writing is, as Orwell wrote, *against a lie*, or, as Mario Vargas Llosa had it, *produced in a spirit of revolt*, and adding overt fabrication on top of both the overt and covert *cultural* fabrications all around me was no revolt at all, was going with the flow. I mean, I wanted to show you *the tree*. But my tree, back when I was a kid drawing, was really a piece of paper with lines and shading that had been filtered through my mind and soul and body— the truth, the mostly verifiable truth, vortexed through the unavoidable fiction of the imagination, in an honest attempt to find a deeper truth, a deeper meaning, a tree more tree than tree, if you will. And this book is the same—I really would like to show you *the artists*— except I have only words, and words and sentences make my portraits now rather than lines and shading. Know all this before you begin.

I chose eight representative artists—all public figures with some notoriety in the current art world, all dead for at least a decade, but none widely known—who created "visionary" outsider art in America—literally art inspired by a magical or mystical vision—all of whom were profoundly shaped by their experiences *as*

Americans, extremely ostracized ones from poor and difficult backgrounds. America was the pressure cooker that made them who they were. Each artist was driven by spiritual necessity, psychological obsession, and a single-minded focus that all but obliterated the rest of their existence as human beings for a short time on the earth. There have been and are dozens and dozens more artists like these in the United States. There is a whole industry and social economy built around outsider art. I tried to stick to writing about artists who had no or at least very little engagement with or understanding of this art industry or social economy, and who went about their business for their own purposes and needs. They made art for a higher power and to save themselves. Even if their ideas skirted the edge of sanity, their motives, I believe, were honest. I appreciate that, admire it.

And, well, maybe just a few more words about me, your narrator through these stories, these sketches, these portraits: I've been interested in, fascinated by, outsider or self-taught art and artists for a couple of decades now. This is no doubt a personal issue with me. I grew up with a paranoid schizophrenic brother who had visions and nightmares day and night, who ended up homeless and then incarcerated, who was a victim and criminal on the streets of this country of ours of three hundred–plus million; I was born in the South, of a long line of working-class North Carolinians and Virginians, all of whom were shaped, without pondering it much, by that American pressure cooker of class and by their distance

from anything like power; and, finally, I lived deeply as a child in a Christian religious belief system where in the end God would win out, and we believers would be delivered from this life of suffering. I think I *get* outsider artists. I think I *get* suffering, which bends and reshapes a person the way extreme sun bends and reshapes a tree. I think I *get* religious or spiritual obsessions and how they arise from our deepest needs. Partly this is because I *get* that people cannot survive without some sense of sturdy meanings. When sturdy meanings collapse, when the world stops making sense, as it did for the artists I write about, we—you, me, them—have no choice but to rationalize and relativize, to create a new world in our minds, and then wholeheartedly believe in it.

This is a simple and personal book—like all my books, like all my drawings and paintings when I was younger, because I believe in clarity and owning what you say— that is driven by three questions regarding each artist: Who was this person? What did he/she do? Why did he/she do it? The answers, to me at least, are fascinating and possibly even instructive.

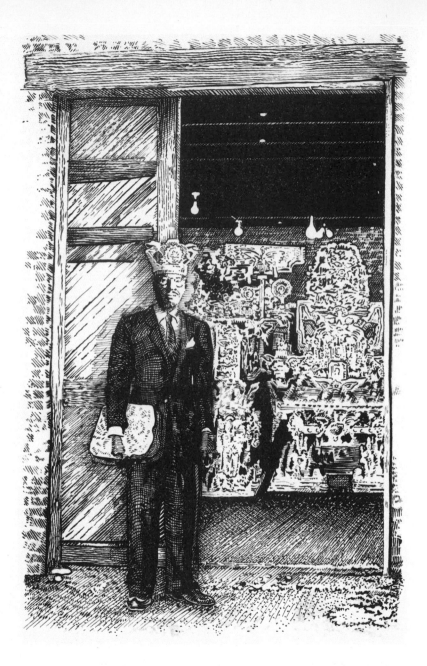

Patron Saint of Thrown-Away Things
A Portrait of James Hampton

1.

Saint James didn't think of himself as an artist. His intentions went far beyond art. He didn't think of himself as a "folk" or an "outsider" or a "grass roots" or a "visionary" artist. He didn't consider himself any of the things scholars have called him since his death in 1964. He didn't even know what those names meant, not in the way they used them, anyway. "Folk"? That's what he called his people down in Elloree, South Carolina, where his sister sat on a splintered porch thanking Jesus for the daylight, where the farmland stretched right out to the hem of the sky, where "The Best Pork Bar-B-Que in the World" was made out behind the Stop-'n'-Go. And "outsider"? Man, that one was easy: every black person in America.

When he began *The Throne of the Third Heaven of the Nations' Millennium General Assembly*, a 180-piece sculpture made from the refuse of a dying world, in

that old rented garage in northwest Washington, DC, where poverty could beat your soul into some new shape, where a man might rather put a bullet into you than shake your hand, he never would have imagined that one day it would be displayed in a museum, under fancy lighting, against a backdrop of majestic purple, where a janitor—a janitor just like him—would come by at night to dust it.

He built *The Throne* to prepare the world for the end-time, the Second Coming of Jesus Christ, our Savior, as prophesied in Revelation. He worked nights in various government buildings in the District, mopping floors and singing hymns from his childhood in Elloree, where I imagine he first saw the face of God when he was just a boy—not a shadow falling down in a corner or something smoldering at the edge of vision, not a feeling tickling in his spine or cloaking him in the Spirit's heat, but the *real face of God*—shining there in front of him one night like an explosion on a drive-in movie screen. It was at that moment that he knew he was chosen, knew he was a saint, knew that he had been granted life, this terrible, beautiful life, to serve God.

2

James Hampton Jr. arrived in his family's shack in Elloree in 1909, slick and shiny with birth, face aimed skyward, screaming like a true Southern Baptist. He was named after his father, a gospel singer and self-proclaimed Baptist preacher who would later abandon his family (a wife and four children, including James) in the early 1920s to travel through the rural South and preach.

In 1928, at the age of nineteen, after a childhood of farm work and family and strict religion, James moved to Washington, DC, to join his older brother, Lee. The city was a new world—bigger, yet somehow claustrophobic, harsher, but beautiful, too—with the great monuments of America rising up into the sky, almost as if they somehow grew right out of the ghetto James and his brother lived in.

For more than a decade, James worked as a short-order cook in various diners around the city, keeping to

himself, hearing faint voices, taking prayer breaks instead of smoke breaks when he took a break at all. At the end of a twelve-, fourteen-hour day, he walked home, slope-backed and exhausted; past men sleeping in alleys and boys hanging out on corners like packs of young wolves; past prostitutes saying, *Hey, little man, hey, Jesus, what I got make you see angels, baby.* He kept his eyes aimed at the ground—cigarettes, bottle caps, a bullet.

He wore his day home with him in a cloud of stink: old vegetables, coffee, meat, grease, garbage. And he could still hear the echoes of clanking dishes and order bells, even in the half-still city night, and somewhere down below all the noise of the world ringing in his head—always ringing in his head—he heard the faint mutterings of God like his own teeth grinding, like his own pulse. He'd shower in the apartment he and Lee shared, read his favorite passages from the Bible—Genesis, the Gospel of John, and Revelation—and sleep the sleep made of hard work. Then he'd get up and do it all over again. Day after day. Month after month. Year after year. The noisy world in his head. And underneath the noise, just underneath it, God.

3.

In early 1942, everything changed. James was drafted. He knew it was coming as soon as he heard about Pearl Harbor on the night of December 7, 1941, right while he was squeezing the grease out of a pink, sizzling burger. Black man like him, healthy and living in a part of the city white people didn't even drive through, he knew. But it was okay, too, a part of God's plan for him. He was a supplicant in the palm of the Father. He was thirty-three now, the same age as Jesus when they nailed him up in sunlight, and he was ready to sacrifice himself if that's what God wanted.

From 1942 to 1945, James served in the army's noncombatant 385th Aviation Squadron in Texas, and later in Seattle, Hawaii, Saipan, and Guam. His unit specialized in carpentry and maintenance, and James made (critics speculate) his first piece of *The Throne*, a small, winged object ornately decorated with

foil, in 1945 on the island of Guam. He returned to Washington, DC, in 1946, after receiving a Bronze Star Medal and an honorable discharge. He rented a room in a boardinghouse not far from his brother's apartment. Then he found work with the General Services Administration as a janitor, not good work, but better than he would have gotten without that Bronze Star Medal and veteran status.

After a brief illness, his brother Lee died suddenly in 1948. Maybe he went to work one day feeling a little down, a bad taste in his mouth and sweat breaking out all over him—he hadn't been to a doctor in years because who could afford a doctor?—then came home, went to sleep, and never opened his eyes. And maybe they buried Lee down in Elloree (this is how I see it) on a bright, sunny Saturday (funeral day), James reading a stitched-together elegy made of Bible passages over the grave, tears rolling down his face, the whole town gathered around, dressed up black as crows, softly singing hymns. But it was a short visit. After mourning and celebrating the ascendant soul of Lee for a day or two, James got on a train and headed back to Washington, sitting in the rear car, the "black" car, the southern countryside smearing by his window. Lee wasn't simply James's brother; he was his best friend, maybe his only friend, and now James, alone but not lonely because he knew all things were a part of His plan, began spending all his time envisioning *The Throne*. Lee and his janitorial job were his only anchors to this world. Now Lee was gone.

Back in Washington, he went out only to work, find materials for *The Throne*, and attend a number of different churches in the city (he didn't believe God would allow for strict denominations and divisiveness concerning His word). By 1949, at the age of forty, he felt the power of God buzzing electrically up his spine. The end-time was coming. He had sensed it during the war, in the stories he heard about what men were capable of doing to one another; he could see it now in the hard faces that hovered along sidewalks, could watch it growing in the people like a malignancy. It was both a curse and a blessing that he sensed it so acutely, felt the world's decay as a dull ache in his bones.

Some days now the low, gray sky would fill up his skull like cotton and he'd forget everything but God, forget who and where he was, and it was beautiful, this kind of forgetting, but then he'd come to on the street, walking stiff as always, General Services Administration uniform tight and clean around his small frame, and he suddenly had this *clarity*; he could see despair like a blanket of living, breathing fog over the streets. It was all he could do not to crumble as he headed to work those days, where he cleaned the floors and toilets of the people who ruled the world.

4.

In 1950, answering the request God had made in a dream, he rented an abandoned garage at 1133 N Street NW from a local merchant, telling him he was working on something that required more space than he had. The garage was down an alley, out of sight from passersby, on a block more dangerous even than his own. It was dark and dusty, with brick walls, concrete floor, and light bulbs dangling from wires that traveled along creaky ceiling support beams. Rats scurried in the alley, darting between Dumpsters. Spiderwebs formed misty veils over corners. It was awful. It was perfect. It was exactly where God wanted *The Throne* to be.

Over the next fourteen years, James found a routine. He worked until midnight, mopping floors and picking up trash in government buildings, then went to the garage to do his real work for five or six hours, listening closely to what God was telling him, finally going home to sleep

when the first pink light of dawn started creeping up the Washington Monument.

Some afternoons and many weekends, he would visit local used-furniture stores, rubbing his hand across coffee tables, feeling how sturdy the leg of a chair was, staring for long minutes at a rickety old chest, then asking about prices in a voice just above a whisper. If he liked something, he'd return later with a child's wagon and a pocketful of folded-over dollar bills soft and worn as tissue paper. He carted away things that had the merchants scratching their heads: legless tables, drawerless desks, half-crushed dollhouses, leaning stools.

Later, you might have seen him walking from a government building with a trash bag full of used light bulbs; or maybe out on the street with a croaker sack, asking bums if he could buy the foil off of their wine bottles. He'd dig through Dumpsters to get green glass, sandwich foil, cardboard. And of course the best thing about working for the American government was how wasteful they were, throwing out perfectly good material because they didn't like the way it looked. Sometimes he'd even get brand-new stuff because someone ordered twice what was actually needed. It made him smile, these finds. The best thing about cleaning up after the people who ruled the world was that they didn't see the real value in things.

5.

Occasionally, after long hours of work, after a face full of government cleaning chemicals and toxic solvents, his brains felt like Jell-O bumping up against his skull, and bits of time disappeared like old pennies. But other days everything was sharp and sensible. On these days of clarity, James . . . *Saint* James turned into God's lightning rod, a cipher for the Word.

He had grown up with the Bible. Bible was his first language. He could remember his father preaching in Elloree, sweat on his forehead like a field of blisters, people standing around in the backyard *testifying. Praise God!* He knew the power of God before he had any inkling of Self, knew later that there was no worthy Self without Him. But when he had these days of clarity, of *vision*, that's when he knew the world was ignoring God and His commandments, knew the end-time was near. Six million Jews, *God's chosen people*, exterminated. He

could barely get his head around that one. And in his own neighborhood, a murder every day. Stealing. Lying. Coveting another man's woman as if it were some kind of game. The list of human cruelties would take you a million lifetimes to recite.

So Saint James wrote ten new commandments for the world. But he wrote them in his own invented language, a series of loops and cursive-looking shapes that occasionally resembled letters. After his death, among stacks of paper, there were some legible notes found. Among them were these messages: "This is true that the great Moses the giver of the tenth commandment appeared in Washington, DC, April 11, 1931." "This is true that on October 2, 1946, the great Virgin Mary and the Star of Bethlehem appeared over the nation's capital." "This is true that Adam the first man God created appeared in person on January 20, 1949. This was on the day of President Truman's inauguration." "This design [*The Throne*] is proof of the Virgin Mary descending [*sic*] into Heaven, November 2, 1950. It is also spoken of by Pope Pius XII."

He also wrote a new book of Revelation. Like Saint John's Revelation in the New Testament, recorded in a special language on the Isle of Patmos and scribbled onto parchment at the speed of a fever dream, Saint James's Revelation was also a kind of stenography from God. On fire with the Spirit when he wrote, he recorded these messages in a spiral notebook. On the cover, in blue U.S. government ink, was written *The Book of the*

7 Dispensation by St. James. Scholars have deemed the book, like the commandments, illegible. The few English words that appear in it, such as "Revelation" and "Virgin Mary," are most often in all caps and misspelled.

"And I saw a new heaven and a new earth: the first heaven and the first earth were passed away . . . " (Revelation 21:1). He knew what that meant, knew the third heaven was the heaven of God, the second heaven was the heaven of the stars and the sun and the moon, and the first heaven, the doomed heaven spoken of in Revelation, was here, now. He was preparing.

He worked through the dark mornings, his joints and back tight as rusty hinges in the damp cold of the garage. Sometimes he'd stop to draw a quick sketch of a plan or to stare at what he was making.

He had built a stage in the back of the garage on which to set some of the pieces. On the larger objects he put rusty metal casters so he could move them to just the right spot. Everything was perfectly symmetrical, had to be, because Saint James was remaking time. That's right, remaking time. Not just representing time as told in the

Bible; he was replicating it with trash. You can see it if you look. On the right is the story of the Old Testament, of Moses and the Law; on the left is the history of Jesus and Grace, the way to salvation.

Saint James understood that the time of God, the only time, was cyclical, always returning. Nothing, no event, was pointless. Life repeated. It was right there in Ecclesiastes: "The sun also ariseth, and the sun goeth down, and hasteth to his place where he arose . . . The thing that hath been, it is that which shall be; and that which is done is that which shall be done." Death simply meant rebirth and a new, more glorious life in heaven, where you would be reunited with all things lost, with Lee and your father and some of the men from the 385th who had died since the war. If you placed your faith in the Lord Jesus Christ, you would never, ever die. Your tears would be wiped away and forgotten. If you placed your faith in Jesus, it didn't matter that you cleaned toilets and lived alone, that sometimes the people on your street scared you, called you a crazy fuck, a hermit, that sometimes the voices in your head called you things even worse, things you didn't want to hear; and it didn't matter that so many of the people you loved had vanished from the earth and your life and you could actually feel the empty spaces they left behind. None of it mattered. And if you truly believed, you were not just a poor man alone in the city among the poor, toiling in a poorly lit garage, babbling to a brick wall; you were not just a janitor, a forgotten vet scraping by on a paltry

check. Your life mattered now and forever. Your life actually mattered.

He worked. He covered bottles and jelly jars and light bulbs with gold and silver foil, which he got from wine bottles and imported beer bottles and cigarette cartons and boxes of aluminum wrap. He used the tops of coffee cans for bases. He mounted upside-down drawers on cheap glass vases, wrapped them in foil. He trimmed the edges of a sawed-in-half table with government electrical cable before covering it all in gold foil. He used kraft paper and cardboard for angels' wings, used carpet rolls to support the greatest weight. He used glue and nails and pins, and sometimes he encased an object in layers of foil until it was exactly the right size and shape.

And then there was *The Throne* itself, the centerpiece of the huge structure, an old red plush chair bought secondhand. He gave it gold wings and put it up high, a seat for the coming Savior. He gave it a high back—four feet, five feet?—of wooden shapes and smaller cardboard wings and bulbs of silver and gold. He named objects for saints and tacked his walls with biblical quotes and a picture of Lee, who was now, God told him, an angel living inside His body, God's body as big as eternity— eternity itself. At the top of it all, this expanse that filled the entire back of a cold, damp garage at the end of a dark alley in one of the roughest neighborhoods in the city of Washington were the words FEAR NOT.

Saint James left the earth before he was ready, before he was finished, even though he once told the merchant he rented the garage from, "*The Throne* is my life. I'll finish it before I die." He had been working on it in the garage for fourteen years, thinking about it perhaps forever, and he wasn't done. He had had stomach cancer for some time, though it had only recently been diagnosed at the free clinic for World War vets. He refused to believe he was dying. It wasn't his time yet. He worked on *The Throne* up to the very end, and the work eased his pain.

Death kept Saint James from knowing so many things about his "Throne." Like just after his death when the merchant brought a reporter named Ramon Geremia from *The Washington Post* to look at it in the garage, where he poked at it and picked things up and probably didn't quite put them back in the right spot, thus slightly altering *the entire history of time*. And he

never got to read the story, which ran under the headline "Tinsel, Mystery Are Sole Legacy of Lonely Man's Strange Vision" on December 15, 1964. And he didn't get to see the photographer out there either, the guy with the Beatles haircut, telling everyone in the local art community what an amazing thing *The Throne* was and how a little black janitor with absolutely no friends and an unknown history had made it over many years. He never got to know that critics would write about his life and work, comparing him to people and movements of which he'd never heard. But most of all, he never got to see *The Throne*, sparkling amid a field of purple in the Smithsonian American Art Museum, never got to stand on those marble floors in his best Sunday suit, his Saint James crown glittering on his head, and be proud of what he'd made using nothing but belief and thrown-away things.

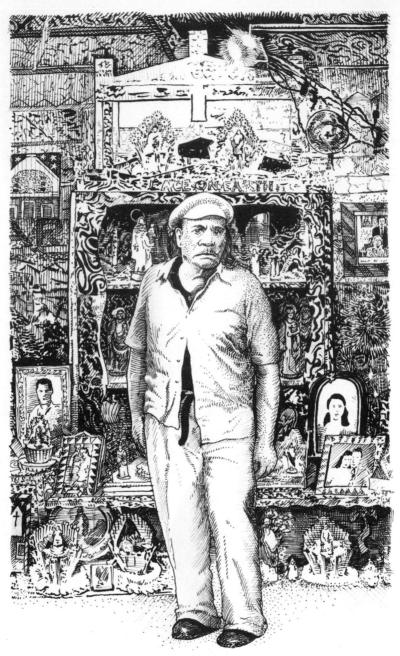

Ghosts in the Mirrors
A Portrait of Geraldo Alfonso

1.

Geraldo Alfonso's mother lived as a ghost in light and reflection, her soul pure energy made briefly visible if he did everything right, if he continued, night after night, his conjuring act. When dusk came and he clicked the wall switch, the interior of her small cottage glowed red, and she moved again through the ornately decorated, mirrored rooms on Catherine Street in Key West. She was even there at the end of his life, in 1998, after his childhood with her as a Santeria "Voodoo Queen"; after his time as a street percussionist in Cuban bands in the '20s and '30s; after his service in the navy during World War II; after his return to Key West from the war; after his short, tumultuous marriage and estrangement from his wife and son; after his defeated retreat back to the cottage to live with his mother, his one true love; after his depression.

He was fifty-seven when she died, and he had never made a piece of visual art until then.

That year a heaviness came. It had always been nearby, at the edge of his perception. Now it covered him like a veil, or was like a shadow stuck behind his eyes. He changed, people said.

He began to create a portal between the world of the living and the dead.

And in light, in reflection, in the hundreds of tiny mirror shards he glued to the walls and ceilings and floors, he could reunite with his mother, have his own image float across hers. He could hear her voice, feel her feminine power, and sometimes see the beams and glimmers of her spirit fling around the rooms of ceaseless glass as he paced through the house at night.

"Miracle Home," he called it. Others would call it an "outsider art environment." Neighbors called it strange. He devoted the final twenty-two years of his life to it, and it was all for her, so that she would keep talking to him, telling her stories, speaking in tongues, the way she did when he was a boy, when she and the other Santeria women on the street of small cottages sacrificed chickens for their blood and performed rituals to speak with the dead. His Miracle Home, he once told a reporter from the Spanish-language edition of *The Miami Herald*, gave him a reason for living.

2.

Alfonso was born in 1918. His mother's name was Sophia Ferrar. She must have come to Key West from Cuba when you could still do that, after the Spanish but way before Castro. She worked in Key West as a cigar maker for most of her life. She had four children: two daughters, Geraldo, and another son, with two or perhaps three different men. They were working-class immigrants in the promised land. Geraldo had no relationship with his father, but it didn't matter. He was his mama's boy, her inspired one, her *makiki*—the powerful little rooster, cock of the walk, strutting along Catherine Street with his black hair shiny and combed.

Here is a story, like many of the stories about Alfonso, which may or may not be true: When he was five, maybe six, his mother became too sick to work for a time. The bills kept coming. The family needed money, needed food. Geraldo took his charisma and his talent and an

old oil drum, his bold rooster self, and went out into the streets to play for the locals and the tourists, who were so impressed they paid him, the little Cuban boy, *el santero*. Mama was so proud she got well again. He saved her spirit, which fixed her body. He saved the family, Sophia's special boy.

3.

Toward the end, when he was seventy-eight, when he was sick in his body and sick in his mind, when he knew the government was tracking him and he was hearing voices, when he and his pistol started having philosophical dialogues about *choices*, he still believed in parts of his mother's religion and its power to open doors between life and death, though most of his art was more directly influenced by Catholicism. He had built a shrine of mirrored glass, Christmas lights, dolls, and framed pictures of his youthful *familia*. In the center was a black, plastic saint, which may have once been his mother's.

In Santeria, a mix of African and Caribbean belief, of Yoruba traditions and Catholic ritual, there is a porous border between human and spirit worlds, and sometimes no border at all. The ancestors are always here. The same year Alfonso died, a mother in New York, a *santera*, with

the help of her twenty-year-old daughter, suffocated her other daughter, a teenager, with a plastic bag. The girl had exhibited signs of what in secular American culture would be called serious mental illness, then diagnosed and pathologized. The mother knew better, though. She was releasing the bad spirits, letting them go back home and hoping, with luck, that she might be able to keep her physical daughter here. What one person—and the state, for that matter—calls murder, another calls a failed attempt to save a life.

Al.

Bad spirits. Maybe that's how Miami came back to Alfonso when he remembered it decades later. He was there in the late '30s, as a percussionist and maraca player in Latin Quarter rumba bands. He was wild, man. *Wild.* People knew him. People remembered him.

He even played for a while with Desi Arnaz, the guy who was later on *I Love Lucy.* Life was a dream of night and sound and alcohol and women. Women were everywhere. Whores. Haitians, Dominicans, Puerto Ricans, and even white chicks, real groupies with that mystified, cherished, overvalued Euro-American skin who hung with Desi and the band. Not dark, beautiful saints like his mama. More like tempting pieces broken off the white devil's soul. All of it blurred through a haze of alcohol.

Miami: Sleep all day. The roar of the band at night. Sweat. Booze and red lights and applause. Band

members waking up in strange rooms, a new woman on the other side of the bed. A life of brilliant debauchery, a life, as his mama would say, of sin. Bad spirits, man. Enough, after a while, to make you dread the dark.

5.

There is no evidence that I can find that he saw heavy action in World War II, when he served on a navy ship in the Pacific. But you might have thought he had if you ran across him in the 1960s, when he was back in Key West with his mother. If you had known him when he was a boy, that little confident kid with the shiny hair and the smile and the drum, you might wonder what happened. Makiki, huh? Dude seemed a little off.

He rode around Key West on a tricycle with big, fat beach tires, along the same route usually, and he worked moonlighting as a musician and selling tickets at Cuban numbers games—an illegal but tolerated form of gambling. He lived in the same ramshackle cottage where he grew up with his aging mother, who people called that old "Voodoo Queen."

You might have seen him in his matching

tropical-print shirts and pants, his homemade knit fisherman hats, a new one almost every day.

"Guy with the macramé hats?"

"Mr. Take My Time on the Tricycle?"

"Señor Tropical Threads?"

By the '70s, tourists had found Key West—found it big-time—and it was a different place. Young people and college students were walking up and down every street during the summer. Drugs were a regular part of American youth culture by then, and an even bigger part of the scene in Key West. Forget about all that idealism and mind expansion of the '60s. Narcotics now were inseparable from our consumerism, our narcissism; they were quick routes to hedonism and escapism, a new and acceptable subculture based on wrecking your mind. Alfonso—Makiki—was just another trip in that context, as funny as he was sad to the tourists, a bit of local color, all dressed up on a tricycle with a blown-out mind.

6.

People get old. Their bodies fail. They die. Everyone knows this but something about the human mind won't let us fully accept that it will happen to us and the people we love.

But what if you get imprisoned by grief?

When someone you love dies, it's like the grief is deep, dark, cold water, and you're in it. At first there is an anchor, a very heavy anchor, attached to your ankle. You sink, you struggle, you can't get out, but most people find a way to keep their nose and mouth just out of the water, barely, to keep breathing and stay alive. Normally, the anchor holding you there gets lighter with time, dissolving like a slow-fizzing Alka-Seltzer, so you're still in the water for a while but your head is up, and then your shoulders, and then, miraculously, you are up on the shore, a new shore. You can look around and try—even though you're exhausted and confused—to

imagine what to do next with the life you have remaining without your beloved, which you never imagined could happen. Not accurately, anyway.

But what if it didn't work like that? What if the anchor got heavier, the water darker and colder? What would that turn you into?

7.

After his mother's death—she must have been around eighty—he began to turn her room into a shrine. He went to the Dumpster of a local glass company. He painstakingly cut out pieces of broken, discarded mirror glass of different colors and began to attach it in intricate patterns to the wood paneling in his mother's bedroom. He worked at this all day long, into the night, and into the dark morning, spending months and then years and then more than two decades creating and re-creating a mirror house of art. He wrote GOD IS LOVE in different-colored mirrored glass on one wall, and left no part of the inside of the house undecorated.

From the outside—if you were a neighbor, say—it looked spontaneous, bizarre, maybe even something to be concerned about. But it gave him purpose, a way to try to defeat death and his drowning sorrow.

He cut out religious images from cards and

pamphlets, Jesus and Mary and Charlton Heston as Moses, framed them in wood and glass, positioned them on the walls near portraits of Mama to protect her. Everything at first was about his mother: a saint, Saint Sophia. He created a visual eulogy of glowing, glimmering personal iconography with the mirrors as a framing device. Through reflection—this is key—he kept himself with his mother. He had found a way to be in every piece of his devotional art. All he had to do was return to it and look.

8.

I have a copy of a photograph of Alfonso toward the end of his life in front of one of the shrines he made for his mother. It was taken sometime in the '90s by a photographer named Ted Degener, who has documented many outsider artists and outsider art environments. I'm looking at it because I'm trying to fathom the final, dark turn his psychology took toward the end, when even the art stopped giving him purpose. The mind of another is a writer's conjecture, and biographical writing is always flirting with fiction, a speculative stab at truth propelled by the available, sometimes scant facts. And the poor and marginalized have less of everything, including, especially, a traceable history.

Maybe, as I write this morning, I'm trying to see if something is detectable in his eyes, his stance, and the artwork around him. The art—and this is true of most so-called outsider artists—was the one thing able to

channel his roiling mental and emotional discomfort, and it became the only way for him to transform, for a time, his loneliness, isolation, anger, guilt, shame, and pain. Perhaps artistic expression pulled from the deepest levels of the psyche should be understood, first, as a physical manifestation of a struggle for transcendence, a fight with death.

Here he stands to the left of the shrine. He is wearing a pink, hand-knit fisherman's hat, a blue, three-button polo shirt covered by a lighter blue short-sleeve dress shirt that seems to be used as an artist's smock, white cotton pants, and a weathered brown belt, the end dangling from the buckle. He is a small man, short and stout. His face is thick, fleshy, and deeply grooved, his nose that of a boxer's—pulpy, broad, and almost loose looking, as if it could detach from his head. He is unshaven, stubbly on his cheeks, with a slim, once-groomed mustache above his thin lips, the kind still popular among older Hispanic men. His eyes are glassy and bloodshot. He looks either drunk or hungover, though I have no idea whether he was drinking heavily at that point in his life. All this is in stark contrast to other photos of him that he hung in his house, near his mother's portraits, from the time he was in the navy. In those he is smiling, dazzlingly handsome, with a head of black, wavy hair, a looker like Desi Arnaz in the early seasons of *I Love Lucy*.

The shrine, if that is the correct word, to his right is a corner bookcase, which was once a simple part of the cottage's interior. But over the years Alfonso covered

every part of the wood with carefully cut mirrored glass, which he decorated in waves and swirls of green, red, blue, and yellow with permanent magic markers. In the shrine, on each of the three shelves, are Catholic religious figurines—Jesus and Mary mostly—trinkets one could find at a flea market. The other pieces, however, are small, intricate sculptures made of clothespin pieces, paper, artificial flowers, and cardboard, each like something from the top of a cake for a wedding in an asylum. The photo shows his otherworldly obsessive love and devotion even while evoking his real-world sorrow and disconnection. He looks terrified.

9.

MTV came to Key West in the '90s. Drunk, half-naked coeds everywhere. Like a filthy dream. He couldn't stop looking out the window. Maybe that's what started the explicitly sexual art. After Alfonso's death, a room in the back of the cottage was found to contain perhaps hundreds of pornographic drawings and multimedia pieces. He had traced photographs onto glass or, sometimes, drew freehand scenes. The works often depicted lesbian sex, but several of them show men with engorged penises either hiding from or going after loose women.

After those early years of religious iconography and votives to his mother—one shrine in the center of the entry room reportedly took him three years— he turned to an obsession with presidents and other political leaders, producing many small works for the house's interior walls—marker drawings, wood frames,

magazine photos, and more mirror glass—devoted to the greatness of America. By the end, though, he was paranoid about the government intervening in his quiet life. He was drawing coeds who had been cast out of the Garden of Eden (which he believed was in Virginia), obsessed with fucking each other, all of them heading for hell, all of them in need of ultimate punishment. In the end, madness becomes its own world, shedding every trace of what you would recognize as sense. It is a kind of drowning.

10.

In 1998, just before starting his ninth decade of life, Alfonso went into his small yard—which was not much bigger than a room in his house—sat down in a dilapidated vinyl chair, and shot himself through the heart with his pistol.

Suicide is often banal when investigated, when pondered, and this one was no different. The world is a very lonely, despairing place for many. People suffer, and get stuck in their suffering, and then, after a while, they believe that there will be no end to this suffering, this exhausting hopelessness about everything. His late art points to dissociation, incoherence, self-loathing, and paranoia. But I'm trying, as I sit here, to turn this around. I'm thinking that if you were a person who, like Alfonso, concocted a shrine to the dead in which your own reflection constantly figured, and was always part of this wall and that wall and the ceiling and the floor,

then you were familiar, in your way, with walking among them. It would seem that you are already dead, and have been for a long time. Death isn't as frightening as people tend to think. So maybe he thought of the pistol shot the way that woman in New York, the *santera* with her sick daughter, thought of the plastic bag: as a simple way to get rid of all these intractable mortal problems, this pain, these bad spirits.

11.

After his death, one of Alfonso's sisters, also a resident of Key West, took over his estate, if you could call it that. Local gallery owners and the county arts council were all aware of the Miracle Home by then. As an outsider art environment, it was highly, if not widely, regarded.

Several people in the Key West art community worked to preserve the Miracle Home, which was in very bad shape, but it was difficult to find the money to do so even with media coverage spreading word about the house. Finally, because of her own financial situation, Alfonso's sister sold it. Most of the work that could be moved was. It ended up in museums, galleries, and private outsider art collections.

I assume the people who bought the house from Alfonso's sister wanted Key West. They wanted the location, the sunshine, and the laid-back attitude. They don't seem to have had any interest in art, or if

they did, they didn't have any interest in preserving the idiosyncratic, lonely vision of the previous owner, who killed himself in their new yard, in a soiled chair that ended up in a landfill. They gutted the place.

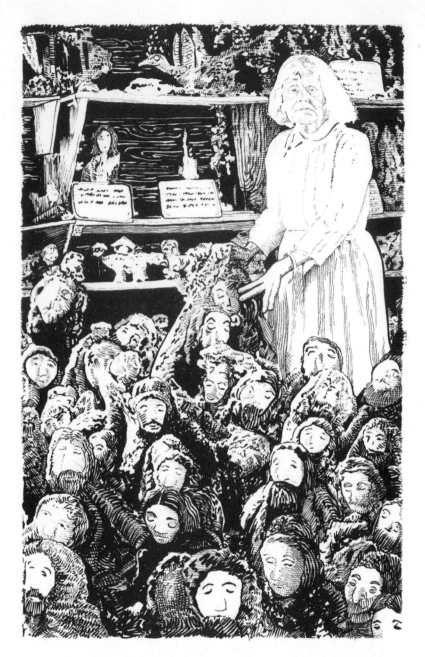

A Place Where the Tears of the Forgiver and the Forgiven Mingle
A Portrait of Annie Hooper

10.

Around her are the faces of the miniature dead, their eyes only slits, as if sewn shut. They are her friends, her company, characters straight from the pages of the Bible. She is not lonely when they are around. Now, at the end of her life, she no longer feels that tug of emptiness, of silence and quiet, which always made her worry, which bred in her a terrible fear for many years, brought her very close to a permanent sickness much worse than death, like being pulled beneath the dark waves of the Atlantic and held there in a panic.

She is in her mid-eighties, with a gray-white pageboy haircut. She wears a handmade dress of peach, the long-sleeve shirt beneath off-white. She is looking down. Her expression is pensive, concentrating. Perhaps she is thinking of whom she will make next. Jesus? Moses? Daniel? Mary? She can barely fit in this overcrowded room.

Her name is Annie Hooper. It's 1982, maybe '83, in Cape Hatteras, North Carolina, and that is her over there, in the corner of her laundry room in this photograph I'm holding, sandwiched between her washer and dryer and the window filled with the leaves of the tree beside her cottage. The rest of the space is occupied by her art—would she have said "art"?—I don't think so—100, 150, maybe 200 biblical figures made from driftwood and concrete—each about two and half feet tall.

Tacked to the walls behind her and beside her are several Styrofoam trays from the butcher shop in town on which she has written messages in black Sharpie. That one there? Look closer. It says THERE IS A PLACE WHERE THE TEARS OF THE FORGIVER AND FORGIVEN MINGLE (AT THE FOOT OF THE CROSS). Sounds like something from the Bible, doesn't it? She wrote that one herself.

2.

She was born Annie Miller on February 26, 1897, in Buxton, a village three miles north of Cape Hatteras. The people here fish for a living in the Atlantic, or crab or clam in the Currituck Sound. You can walk from the Atlantic on the east to the sound on the west in less than half an hour even at the widest points of these Outer Banks. This strip of land, her home, was formed by a hurricane and may eventually be removed by another. People here know about storms.

But if the place is isolated, she, as a child, is not. She has twelve brothers and sisters. She has fourteen foster brothers and sisters. It is like living in a schoolhouse, only no one ever goes home. No one ever leaves. And she is happy. Little Annie in this world of children. They catch fireflies in jelly jars. They play tic-tac-toe on the beach, using sticks to draw the O's and X's. They hold out their arms while standing on the fine, squeaky sand when

the east wind roars, churning the ocean into a chaos of white and brown, and she feels as if she is flying, her hair whipping around her face as she squints in the sun. They run screaming, flinging their swatter arms, when the greenhead flies come in on the southwest breeze from a scorching Bermuda high over the Atlantic that drags them from the swamps on the west side of the sound. The children sing together at church in the choir. They praise the Lord.

And children work at the turn of the century, are an important part of the machinery of the village. Parents procreate for love, for human urges, sure, but also out of necessity. Some children live; some die. Only fools don't stock up on them, have a few extras when needed. Most families here have five, six, eight, fifteen kids. All God's children; just ask the preacher at the Hatteras Assembly of God. It is a busy, noisy world. Every minute feels *occupied* to Annie.

Annie's school year is built to let children work— before school, after their lunch, all through the best fishing seasons. Annie excels at school, prefers it to the work of fish and crabs—the salt-turd smell; the clinging seaweed; the rotten, wrinkled feet; the jellyfish electrifying your forearms all day long; sea lice itching at the borders of your clothes.

Annie's parents are proud of her. She is smart, and an avid reader. She writes poetry. She reads novels. She would like to be a novelist, which is a woman thing do to (she does not know a man who would admit to

reading a novel), but who would read her books? Only a few hundred people live here. She would like to be a preacher, too—a novelist and a poet and a preacher!—but only men can be clergy, *which is silly*, she thinks to herself as she walks along the beach. *I can teach about God better than any boy I know!*

In her mind, though, she is many things—a nurse, a dragon slayer, the first female boat captain, sometimes an angel or a messenger. She is Eve in the Garden of Eden, and she is able, with her cunning, her smarts, her creativity, to trick the devil into slithering away.

3.

In 1913, at the age of sixteen, Annie married John Hooper, a fisherman who came to the docks on the sound side near her home, whom she must have first seen and then met while working or accompanying her family down to those docks to see what was being brought in (an entertainment then)—tuna, drum, hammerhead shark, marlin. Some of the most impressive fish in the world come from the Gulf Stream, are brought in through Oregon Inlet and gravity-slapped ice-covered onto Outer Banks docks.

Annie liked that the best fishermen had the biggest boats, the most handsome crews, men who leapt onto splintered planks in their squeaky, white rubber boots, their forearm muscles rippling when they lifted a fish or tugged a rope, their necks wrinkled and the color of too-old jerky. And these men talked as if they had marbles in their mouths, or rubber faces. They weren't

from Currituck or Albemarle; they were from "krteck" or "el-mar." They said: "Say, bubba," "post-a-be," "aw-ight-I-reckon." John thought Annie was "a might putty gul": a mighty pretty girl. She was indeed.

She moved with John to Stumpy Point, a small village across the Currituck Sound, a place accessible to Hatteras then only by boat. They had a son, but only one, which is unusual, makes me think perhaps Hooper could not have any more children after that.

It was a happy time at Stumpy Point. She and John and their son went by boat to see her family on some Sundays, to feast on seafood and corn and homemade pies and fried chicken and ham. Family was what gave her purpose. Her love for her people. She did not like to be alone.

For two decades, beyond the usual ups and downs of life—bad fishing seasons, harsh droughts, too much rain, hurricane scares and nor'easters, the deaths of loved ones, the First World War—Annie seems, overall, to have been happy, a popular person in her community. She taught Sunday school and was a brilliant teller of biblical stories to the children. She had many of these stories—Samson and Delilah, Jonah and the Whale, Noah's Ark—memorized, ready to perform. The children sat cross-legged in a circle every Sunday morning, waiting to hear the story Mrs. Hooper would tell next. And afterward, they all drew pictures from the story, clamoring to show her what they had made. "Wonderful!" she would say. "Whoa! Now *that* is a scary

whale. I didn't know a mouth could even be that big!" "That Sampson sure had some giant muscles! He must have eaten right and exercised!"

At home, at night, just before bed, she wrote poetry— about the ocean, about God, about her worries that she might lose all that she had. She knew some fancy words. Words like "tenuous." She felt some nights the world was *tenuous*, that the darkness of the Atlantic could enter her mind if she wasn't careful, diligent. Even when she was only seventeen, she felt as if she had been an adult for a long time. She missed her childhood—those twenty-six brothers and sisters and friends. And there was something else. She didn't dwell on it, it wasn't a big deal, nothing to talk about with John, just a feeling really, a little thought sometimes, but in some part of her she knew that in the end you lost everything and left this world as you came into it, stripped of time and company, alone.

She imagined it was like drowning.

4.

World War II came. She was forty-four. It was strange, unfair, the way you could go through your life, just day to day, mundane, sunrise, sunset, you and the world, you and your loves, and then suddenly history came sweeping in. Just when you felt you had control, here came a force that felt as big as God to you to tell you that you didn't. Everything could be taken away, swept out on a current of senselessness.

She hadn't thought much about the Japanese emperor, or Hitler and the Nazis, or Mussolini's fascists. What was a communist, anyway? Were they with us or for the other side? Her preacher had always said the communists would ruin America. And what did everyone want in this war beyond the death of other people and the creation of absolute sorrow? Hitler had the postage-stamp mustache, she knew that, and Stalin—was he good or bad?—had the shop floor–broom mustache.

The mustache men of the crazy war. Who could make sense of this?

There had been bouts of depression by then. They came; they went. Like that tide and the rotten-egg smell that came and went with it. If she was quiet, took some time away, took long walks on the beach, they'd leave her alone after a while. But all this patriotism was going to kill her. *Don't be so nervous,* people told her. But how could she not be?

Her husband, in the early '40s, took time off from fishing and left, with most of the other men from the village, to go work for the military shipyard up in Norfolk, Virginia, which was a five- or six-hour drive on country roads back then, though it was only 135 miles away. Her son—this was the worst—enlisted in the military, was shipped off to the war in the South Pacific. She was alone for the first time in her life. The tides of her depression came rushing in.

5.

She had imagination, Annie did. But now, alone in the house, it was her curse. She thought of her son and heard artillery fire thudding and bullets singing past her ears. Her *son*, her little boy, her only child, was getting shot at every day. What mother could accept that? And so much of her time suddenly was unoccupied—minutes and hours and days of seeming emptiness—and all she did was think. Think think think.

She took walks. She cried. She tried to keep teaching Sunday school, to have a "stiff upper lip" for all those kids, almost all of whom had a father or brother or uncle in the war, and many of those fathers and brothers and uncles—unbeknownst to her bright-faced pupils— would never return. She cried. Perhaps she saw the town doctor, who would have made house calls back then. He would have told her to rest, but rest was the worst thing: more empty time. Looking up at the ceiling in her musty

cottage. Hearing the wind against her windows, which sounded, when it gusted, like bombs.

6.

Finally, understanding that things were getting bad, that Annie was, well, kind of losing her mind, John sent for her. He moved her into a large house in Norfolk. He was gone most of the time, working long shifts on the ships. He suggested maybe she could take in a few boarders for company. People from all over the country—Nebraska, Minnesota, Idaho—were now in Norfolk, working in some way for the U.S. war effort. She could help them by offering an affordable place. Maybe they would help her to keep her mind off of all the death and mayhem in the world.

First there were two, three boarders. Then five. Then— "so many people need help, John"—twenty, thirty, thirty-five. Mrs. Annie became the boardinghouse mistress of Norfolk, Virginia. This gave her a purpose, and her deep depressions all but disappeared. The minutes and hours were filled up again. She had work work work. Cooking

and cleaning and laundry, and all of it was for the good of her country. It reminded her of childhood, being always in the noise and company of people. Glorious.

When the war ended in 1945, Annie's boarders packed up to head for home—back to the plains, the mountains, the deserts of America. John and Annie returned home, too, now moving into a cottage in Cape Hatteras, back across the sound from Stumpy Point. Annie was relieved at first to be home again, where she had grown up, but it didn't last long.

Her husband, I assume, went back to commercial fishing. Annie found herself alone again much of the time. Her son had survived the war. Hallelujah! He was supposed to return home, presumably to fish with his father, but instead he was admitted to a veteran's hospital in western North Carolina, though I can find no record of what his injuries or ailments were. He was there for a year.

That year Annie's depressions returned, only much worse than before. She had blackouts and memory loss.

She could get so confused, so tangled in her thoughts, that she frightened her husband, her extended family in the area. People whispered that she'd gone and lost her mind.

8.

Robert Burton, in his treatise-cum-personal-essay *The Anatomy of Melancholy*, a classic of seventeenth-century English prose, suggested that the best medicine for the saturnine temperament is movement, one foot in front of the other. Gets the blood moving, clears the cobwebs from the head.

That's what Annie did. She walked along the beach, the tide and waves at a low roar at all times. She was forty-nine, almost fifty, and her idea of art was poetry, church choir music, Bible stories, and tame romance novels. She was not handy. She did not make things.

But one day, walking the beach, she saw driftwood stacked and leaning in a peculiar way. Much so-called primitive art has begun in just this way. A bush looks like deer antlers, so someone makes it into a deer; a stump looks like a hunter crouching, so a man carves out the shape to clarify what he sees, to represent something of

his experience in the world. I imagine she stared at the driftwood, her thoughts never far from her Bible stories. She walked around it. She thought it looked—or could look—like an angel. She carried it home.

9.

She used concrete to make a base for the piece of driftwood. Then she used more concrete to form an angel's head and wings. When she was done, she painted it using paints available at the local hardware. She found more driftwood, used more concrete and paint, and made a biblical scene in the living room. From a distance of ten feet it looked something like those Cabbage Patch dolls so popular in the United States in the '80s. She took a Styrofoam butcher's tray, labeled the scene, and thought that perhaps people would like to look at it. She looked at it. She was proud of it. She moved things around. There. Just right. Her first works of art.

That's how it started—as a way to fill up all those sad, unoccupied moments. She made another scene, then another. Her husband thought it strange after a while, especially as the rooms filled up, as it became such a compulsion. But she was a little better now, and

seemed as if she was getting rid of her sickness, whatever it had been, as she continued to create. He decided not to complain.

Moses and the Burning Bush. Daniel in the Lions' Den. The Sermon on the Mount. The Last Supper.

For forty years, from the time she returned home to the Outer Banks after the war until she died in January of 1986, she worked on one biblical scene after another, labeling each one on another Styrofoam butcher's tray, filling her house so full of tableaus that through most of it you could walk only by putting one foot in front of the other, tightrope-style. By best estimates, she made more than five hundred scenes, which she separated with Christmas tinsel and plastic flowers, and twenty-five hundred figures, always using the same process. People—both locals and tourists—stopped by to look around. They talked about old Annie Hooper, who used to teach Sunday school just down the road.

10.

In 1970, Roger Manley, who would become one of the leading voices and curators of the outsider art boom of the 1980s and '90s, stumbled upon Hooper's obsessive output when he was hitchhiking on the Outer Banks and was picked up by her grandson, Buddy (the coincidence here is almost cosmic). He was invited into her cottage that had been turned into, by then, an off-kilter museum of biblical history. He couldn't believe it. He took photos. He told his friends back at Davidson College, most of whom found the story hard to believe. A woman who could barely walk through her own house because of the biblical characters she'd made from driftwood and cement and hardware-store paint?

In 1995, nine years after Hooper's death, Manley curated a show of her biblical scenes at the Visual Arts Center at North Carolina State University. It included

all twenty-five hundred figures. It was the largest single-artist show of outsider work ever organized.

On my desk here is a newspaper article from the *Deseret News* about the show:

"Manley says he took great pains to present the work as Hooper would have if she had had the same space . . . He spent the week before the opening sweating such details as putting together a Nile River filled with crocodiles and dead babies, and making sure he had enough plastic greenery . . . Plastic flowers are part of the exhibit because Hooper used them to decorate the figures in her house. Blue AstroTurf is being used because Hooper had blue shag carpeting."

At the end of her life, though she outlived her only child and her final project was to make fifty grieving mothers, according to both Manley and her grandson, she was content, even happy. She loved to tell visitors about her biblical scenes. "She viewed the world as God's creation," her grandson once told a reporter. Through her art she devoted herself to celebrating this creation, which, in a way, cured her.

*Do You Think Your Soul Believes in You? (from a
commonplace book)*

1.

Those original solitudes, the childhood solitudes
leave indelible marks on certain souls. Their entire
life is sensitized for poetic reverie, for a reverie
which knows the price of solitude. Childhood
knows unhappiness through men. In solitude,
it can relax its aches. When the human world
leaves him in peace, the child feels like the son
of the cosmos. And thus, in his solitudes, from
the moment he is master of his reveries, the child
knows the happiness of dreaming which will later
be the happiness of the poets. How is it possible
not to feel that there is communication between
our solitude as a dreamer and the solitudes of
childhood? And it is no accident that, in a tranquil
reverie, we often follow the slope which returns us
to our childhood solitudes. —Gaston Bachelard

2.

The origin of the world and the annulment of the
world are not in me; neither are they outside me;
they simply are not—they always occur, and their
occurrence is also connected with me, with my life,
my decision, my work, my service, and also depends
on me, on my life, my decision, my work, and my
service. But what it depends on is not whether I
"affirm" or "negate" the world in my soul, but how I
let the attitude of my soul toward the world come
to life, life that affects the world, actual life—and
in actual life paths coming from very different
attitudes of the soul can cross. But whoever merely
has a living "experience" of his attitude and retains
it in his soul may be as thoughtful as can be, he is
worldless—and all the games, arts, intoxications,
enthusiasms, and mysteries that happen within
him do not touch the world's skin. As long as
one attains redemption only in his self, he cannot
do any good or harm to the world; he does not
concern it. Only he that believes in the world
achieves contact with it; and if he commits himself
he also cannot remain godless. Let us love the
actual world that never wishes to be annulled, but
love it in all its terror, but dare to embrace it with
our spirit's arms—and our hands encounter the
hands that hold it. —Martin Buber

3.

God exists, if only in the form of a meme with
high survival value, or infective power, in the
environment provided by human culture.

—Richard Dawkins

4.

Art lost its basic creative drive the moment it was
separated from worship. It severed an umbilical
cord and now lives its own sterile life, generating
and degenerating itself. In former days the artist
remained unknown and his work was to the glory
of God. —Ingmar Bergman

5.

Creation happens to us, burns into us, changes us,
we tremble and swoon, we submit. Creation—we
participate in it, we encounter the creator, offer
ourselves to him, helpers and companions.

—Martin Buber

6.

He who is unable to live in society, or who has no
need because he is sufficient for himself, must be
either a beast or a god. —Aristotle

7.

Only what touches us closely preoccupies us. We
prepare in solitude to face it. —Edmond Jabes

8.

Every man must do two things alone; he must do
his own believing and his own dying.

—Martin Luther

9.

We are all sentenced to solitary confinement inside
our own skins, for life. —Tennessee Williams

10.

Faith has to do with things that are not seen, and
hope with things that are not at hand.

—Saint Thomas Aquinas

11.

It is the want to know the end that makes us
believe in God, or witchcraft, believe, at least, in
something. —Truman Capote

12.

Why, sometimes I've believed as many as six
impossible things before breakfast. —Lewis Carroll

13.

Faith is an aptitude of the spirit. It is, in fact, a
talent: You must be born with it. —Anton Chekhov

14.

It's ridiculous what I do. I can't believe in it—but I
have to. —Damien Hirst

15.

I had therefore to remove knowledge, in order to
make room for belief. —Immanuel Kant

16.

But I'll tell you what hermits realize. If you go
off into a far, far forest and get very quiet, you'll
come to understand that you're connected with
everything. —Alan Watts

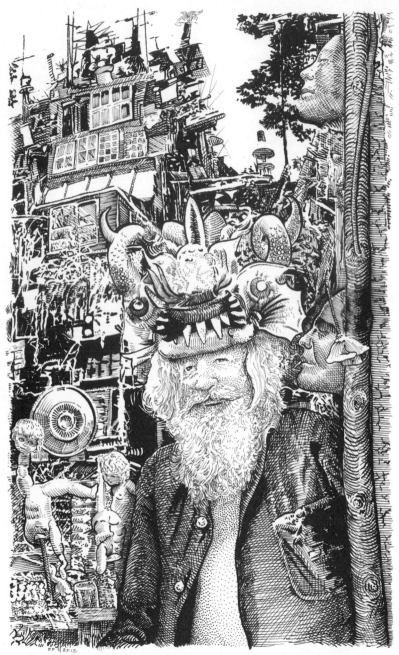

Mountainous Harmony and Everlasting Peace
A Portrait of Clarence Schmidt

1.

Kingston, New York, 1973. An old man is rotting away in an adjustable hospital bed in a state-subsidized nursing home. He tells the nurses he is from Ohayo Mountain, in the Catskills, ten miles north. He is a mountain man, a maker of monuments. He is *the artist of the world* and the world's *first true pop artist.*

But the medical staff have their jobs to do—medications, bedpans, pillow adjustments, vitals—and people at the end of their lives are often touched by something, something magic and a little crazy. Anyone who has stood near death long enough will tell you this.

The nurses don't have time to hang around in this man's small, musty-smelling room and listen to him, though it's clear he has a lot he'd like to say. For instance, what he once told the photographer Gregg Blasdel and the art historian William Lipke: "I'm a cross between Rip Van Winkle, Paul Bunyan, and there's a lot of Robin

Hood in me. I became some greater part of [Ohayo] mountain . . . Why, when I walked along the road, the trees bent down on my behalf."

What these nurses know from his chart is that he has a weak heart, poor circulation, and diabetes. He has possibly been living with untreated diabetes for decades; his blood sugar readings like a stock market ticker.

The state sent him here when he'd completed a stint of "mental observation" at another facility, and after it was discerned, by the proper authorities, that he was not a danger to himself or others. Earlier, he had been homeless, sleeping in doorways and under the eaves of gas stations in what some of the nursing staff think of as the "hippie town" of Woodstock.

He's heavy, with a round belly—even after living on the streets, time in a mental institution, and nursing-home food. He has a big, gray beard and a mane of white hair. His eyes are wide and glassy: Santa on LSD.

This guy, this old man in a hospital bed in a dim room in 1973, has quite a story to tell, if someone would listen. His name is Clarence Schmidt. He is—just ask the nurses—possibly the greatest American artist of all time.

2.

Schmidt was born in the Astoria section of Queens, New York, in 1897. He attended public school there, and was a decent student. He dropped out of Bryant High School in his teens to learn how to be a plasterer and stonemason. It was a trade a man could make a living doing, and it would become a foundational element in his later art.

School, back then, held little practical promise for the working classes; retention rates were low. He was bright outside the classroom, though, and a quick study, good with his hands. Years later, if anyone ever asked him about his schooling, he would say the best thing about it was that one of his fellow students was the crooner Ethel Merman. He heard her sing before she was known. They had almost been friends.

He worked as a tradesman in New York City through his twenties and thirties and had, it seems, a stable life.

He was married to a woman named Grace, a cousin. He made a good living by the standards of the time and place and saved his money. But he dreamed of the outdoors—the mountains.

He had five acres of family land on Ohayo Mountain, overlooking the Ashokan Reservoir, which was reportedly left to him by a male cousin. He began to go there with his wife for the summers in the early 1930s, and he made acquaintances in the town of Woodstock. Soon he began to work as a general laborer and town handyman. He was adept with various kinds of materials, including wood, stone, concrete, and plaster. He painted like a professional. He wasn't a plumber, but he knew how to run pipes. He wasn't an electrician, but he understood the basics of the trade.

He moved full-time to his land on Ohayo in 1940. It was a place so full of life—but not people—and so densely green and flowered compared to the hard surfaces and grays of New York City that some mornings he would just walk around breathing and listening, breathing and listening.

Around this time, in the early forties, his life, his mind, his whole system of values . . . *shifted*. Shortly after his move to Ohayo, his wife is no longer in the picture, or in any of the stories about him. What happened? Where did she go? Why did his life, his mind, change so drastically? Some of the mythology about Schmidt—to me, the most believable—suggests the relationship was simply unconventional and that she went elsewhere,

though still in the Catskills, to live with a bevy of cats. The truth, I'm afraid, is lost. In 2009, Grace died a very old recluse in Glenford, New York, and Clarence's ashes were found to have been in her possession for thirty-five years. What is known, and what I can say with certainty, is that in the early '40s Schmidt was living on the mountain permanently, happy and focused, deep in nature, about a thousand feet closer to the sky than he was in Queens. His old life—who he used to be—was gone. A new life began.

3.

The sky. Nature. Light as it shifts through the hours of the day, the seasons of the year. These were important elements to him when he built his first house, which he called Journey's End.

The house began as a simple cabin made of railroad ties. He then covered it in a mixture of paint, varnish, and tar—which produced a black, marbled look that barely resembled what it once was. He did this for aesthetic reasons as well as to seal the wood from the elements. Into the wet tar, he threw small pieces of different-colored broken glass from bottles and mirrors. His new home sparkled in the bright summer light and the verdant green of the Catskills. In winter, it reflected the many shades of gray of an upstate New York sky.

Some locals, even early on, thought he had gone insane. "They think old Clarence has gone crazy up there," he once told a visitor. "He starts throwing cracked glass

[at the house] and sings 'My Old Kentucky Home.'" He laughed when he told this kind of story, a story about how strange people thought he was. He didn't care. He saw himself as a new kind of artist for a new kind of world.

4.

He eventually sold Journey's End for the land it was on. As a skilled stonemason trained by his father, he then started a massive undertaking, years in the making, to build bluestone, terraced walls down the side of a steep slope. He did this partly to stop the hill from washing down the ravine during the snowmelt and the rains of spring. At the top of this slope was a country road. He moved every large and small stone by himself. He planted the terraces with the most beautiful local flowers he could find. He was already thinking of the hill as a canvas for his imagination.

He began a second house in the midst of the terraces, a one-room log cabin against a large tree, which he used for support. It isn't clear when exactly he got the idea to turn this cabin into a seven-story mansion of random angles and labyrinthine rooms that seemed to serve no function beyond its aesthetic potential.

He covered his cabin in tar and bark, as if to camouflage it. From there he erected one room at a time, upward and outward. He used existing walls as foundations for new rooms, the composition intuitive rather than planned. Some of his work, occasionally, collapsed and needed to be redone. By 1953, the house was already five stories high, and he continued to live in the original cabin, now a room invisible from the outside and hard to find if you didn't know the way. He called this his "inner sanctum."

His idea was to bring the outdoors in, have plants in the house, as well as branches and grass. He wanted to raise mushrooms in some of the rooms, which were completely dark most of the time. He gave up on the idea of making his own small lake in the house when he realized it was too hard to figure out how to do that without flooding the whole place.

5.

From afar, in black-and-white photos, the house, once it reached its full seven stories, looks like a contemporary on a hill, the home of a rich person who bought the view and lives luxuriously on it. You see beautiful houses like that on the hillsides and mountainsides of Vermont and upstate New York. It is only when you close in, and take a longer look at Schmidt's place in the photograph, that you see the house is cobbled together from logs and cut boards found or donated or bought cheaply. On one side of the structure, you can count more than fifty windows—each one, like the wood, from some unique origin. It is hard to find two windows that match. You have to marvel at the ingenuity, the engineering problem solving, the *scale*. He was regularly in danger while building. He referred to the mansion as My Mirrored Hope or the Mirror House because of all the windows and his use of foil and glass for the purposes of light and

reflection. ALL FOR ONE AND ONE FOR ALL reads a sign
at the entrance to the property.

6.

Entering the house in the early '60s, you could see how his focus had changed now that the outer structure was in place. The rooms—dozens and dozens and dozens of rooms—had become small or large environments in which to experiment with the use of nature and assemblage and found-object sculptures.

He used sticks and branches wrapped in foil, scrap boards, and mirror and glass pieces of different sizes. He filled the rooms with fake and real flowers. He then ran Christmas lights through the house, often with the wires covered in more foil—a slow process of decoration. In some of the rooms, including the "inner sanctum," almost every surface was covered in glass or foil or wood painted metallic silver. He filled his sanctum with dead TVs as a way of having more reflective surfaces.

Though Schmidt, unlike most self-taught artists, very much considered himself a serious professional, he

did not believe in any art world of galleries, museums, collectors, and buyers—that was not what art was about—and he refused to sell anything. (He was once offered $40,000 for a piece of his house, but what was money to him? Just paper!) His hoarding, his obsessive collecting of almost anything potentially usable, resulted, finally, in acres of material stacked on material. Around his property there was scrap metal, wood, glass, car parts, whole cars, wagon wheels, bed frames, fake flowers, wiring, dead appliances, blankets, bulbs of every size and kind, holiday yard decorations, doll parts, mannequin parts, various kinds of furniture, and so on. From the air, it would have resembled a wrecking yard. He was the artist and the collector of the great artist's work. His Mirrored Hope was a museum filled with and surrounded by small galleries he visited, as an astonished spectator, every day.

70.

I am looking at a photograph of Schmidt standing in a cleared path of his roof garden, a section of land at the edge and top of his property. It was a space above the house, adjacent to the two-lane country access road, along which several neighbors lived, most of whom were understanding—or at least tolerant—of Schmidt and his colossal undertaking. He poses among dense piles of debris, which include tires, mirrors, stone pedestals, scrap wood, dolls, more mannequin parts, branches wrapped in foil, car rims, and more wood. He wears a conductor's hat, overalls, and a jean jacket. His white beard has gone years without a trim. He is the proud maker of all this. What a smile!

Eventually, as the garden grew and spread and finally moved over property lines, the county was called in to put a stop to it. Schmidt didn't want trouble. By all accounts he was a jovial and well-liked hermit, tolerated

by the locals in live-and-let-live Woodstock, even adored by some. It is quite possible that he didn't realize, in his building and collecting mania, that he had moved off of his own property until the county pointed it out. He stopped work on the roof garden—it was close to complete anyway—and decided to go to work at the bottom of the slope, below and alongside the house, where no one could see to complain.

8.

He began to construct shrines. What else to call them?
He was able to get rubber body parts from the army,
which they had once used to study wounds made in
flesh by different types of weapons at a nearby facility
and were now discarding. Schmidt made many sinister-
looking assemblages of wood crosses with sawed-off
hands and heads attached, most of them covered in tar
or painted silver or wrapped in foil. He also began to
make grottoes devoted to President Kennedy. In these,
he framed a cutout picture of Kennedy, and covered
it, except for the face, in tar and varnish, then painted
around it, building up an elaborate construction of
wood and more rubber body parts.

Some of his final artworks were self-portraits. For
these, he framed a picture of himself, usually taken by a
visitor and given to him as a gift, varnished over it, and
made it the centerpiece of a kind of multimedia altar. He

commemorated himself as a person of profound vision and talent, placed here on earth to spread the word of peace and love for all mankind. A secular saint. "Look at all I done," he liked to say, standing among his works. Who else could have done this?

9.

On January 6, 1968, Schmidt's seven-story mansion, large parts of which he had covered in his highly flammable tar mixture, burned to the ground after a windstorm blew a large maple branch onto his amateur wiring. "Everything shot up in flames," he later said. "It created an aurora borealis that you could see for miles and miles." Because of the tar, the varnish, and the self-taught wiring scheme, the property burned for days. It melted into ashes and rubble.

Schmidt moved for a short time into a Woodstock hotel, presumably on charity. He moved back to Ohayo that spring, living in a broken-down station wagon. Quickly, however, he began to use the car, a Studebaker, and another large tree as the beginning of a second house, which he called Mark II. He built rooms around and above the car with wood and scrap already around the edges of his property, and he began to live there. He

covered the outside of his new home with silver-painted and foil-wrapped branches, beads, doll heads, and aluminum foil. It resembled a giant, silver sea urchin. The Studebaker became invisible from the outside, and he called it his new office, a place to think, dream, design.

Around the Mark II, he constructed what he named Silver Forest. It was a set of crushed, bluestone pathways through the grass and woods. Along the paths, he covered trees and branches with more foil and silver paint in what he once said was an homage to the astronauts and NASA. He impaled doll heads and rubber hands and body parts on the branches. His stated mission was to take the edge off of all the suffering of the world. He would leave all his work for "posterity" and people could come to Ohayo to see it, see that there was more to life than war and suffering and violence and pain. There were astronauts who came closer than anyone in history to God. There were things to believe in.

10.

After a second and final fire, probably also related to his wiring, one which destroyed the Mark II and most of the Silver Forest, Schmidt had no choice but to go to Woodstock and try to get food and shelter from handouts. His health was clearly failing by then, exacerbated by the stress of losing everything, his undiagnosed diabetes, and his homelessness. His behavior, beatific on a mountaintop, played less well in the suburbs, making some locals concerned about his mental state. Eventually, he was picked up by police and sent to a psychiatric hospital.

On the streets and in the hospital, he wrote about his mission:

"I am still going to carry on with my philosophy which is the science of universal free love one for all and all for one it is just as simple as that and just as easy to observe. How heartless can anybody get in this world I

am no criminal, I have always led a ritually cloistered holy existence, I have hallowingly dedicated my very life body and spiritual soul I have overwhelmingly dedicated with all of my anxious hearts blessings a new and glorification world all tenderly wrapped up with mountainous harmony and everlasting peace."

11.

In the nursing home, he was quite a character, oddly smart, eloquent, and entertaining. He was always telling the nurses stories about his mansion and his art, his power to change the world for the better. I imagine the staff liked Schmidt, regarded him as a kind of super-hippie, a hermit from up on Ohayo Mountain, a guy who dropped out of society and made his own world, his own rules for living. I doubt they believed most of his stories. How could they? A seven-story mansion? An altar for the astronauts? The army giving him a truckload of body parts?

Even when it was clear he would not leave his hospital bed until he was a corpse, clear that nature would reclaim his land as nature always will, he continued to tell the nurses he planned to return to Ohayo one day. "I've got to live to be 185 to complete what I want to do," he once said. "I'll startle the world with what I'm going to say

and do . . . Believe me: I'm working all night now. I'm
doing it in my mind. I'd lay down my life for art."

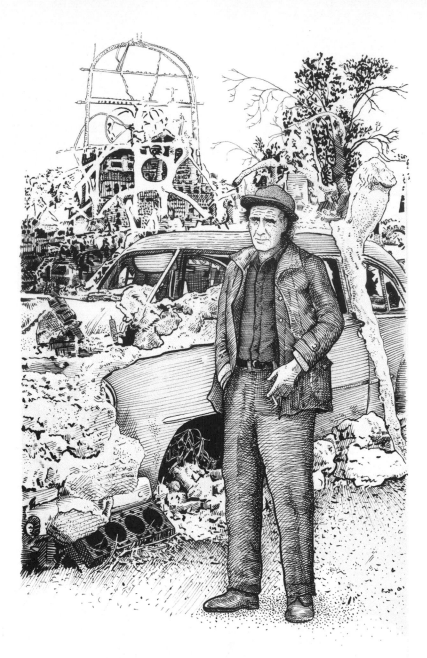

Residential Chief Artist of Nothing
A Portrait of Frank Van Zant (a.k.a. Chief Rolling Mountain Thunder)

10.

He had a dream in 1965. The Great Spirit had turned him into an eagle, a man-eagle, a man with eagle wings, and he soared over the barren Nevada mountains, near Sacred Canyon, snowcapped and boulder strewn and cold as iron, then out over the desert floor with its gray-chalk sand and scrub brush and jackrabbits and coyotes, and below him were people, lost and alone and in need of guidance, some of them children, many of them crying, and he looked down on them and knew that he must build what he would later simply call the Monument, a sanctuary from the world in the end-times, an outpost of concrete, rock, scrap iron, abandoned automobiles, discarded lumber, bottles, car windshields, animal bones, other assorted trash, and his remarkable, freehand cement sculptures of Native American motifs and heroes, including Sarah Winnemucca, Standing Bear, and the Aztec god Quetzalcoatl. It was a place,

he once said, devoted to the power of "pure and radiant hearts."

Or maybe he was told to make the Monument even earlier, in a prophecy. When he was younger, when things were going wrong, when he was feeling lost after World War II, all that death and noise and waste, he went (so the story goes) to a medicine woman for help, to fix his broken spirit, and she told him—as he stood, I imagine, almost in a trance—that in the final days of the earth, when the white man had destroyed everything with his greed and selfishness and war, there would rise up a place called Thunder Mountain. He would be the warrior who brought it into being, a powerful chief with a thunderbolt in his hands.

Or maybe—the materialist's view—he was just grounded there in 1968 when his 1946 Chevy pickup broke down as he and his new wife—who looked barely out of her teens, a kid he picked up somewhere on his travels—were driving through the high desert outside of Imlay, Nevada, 130 miles northeast of Reno. He was calling himself Chief Rolling Mountain Thunder by then. He was a poor man with few possessions, $36 in cash and coins, and a lot of wreckage and sorrow in his past. He had lived several lives already, his identity perhaps his greatest and strangest work of art. He used, as he would later say, "the white man's trash to make [his] Indian Monument."

2.

His real name was Frank Van Zant. He was born in the
small town of Okmulgee, Oklahoma, twenty-five miles
south of Tulsa, on November 11, 1921 (I have seen his
birth date listed as 1911 also). His mother was part
Creek Indian. His father was a white man of Dutch
ancestry (this *seems* to be the case—it's what *he* says in
a documentary—but I have seen the opposite stated as
well—his mother white, his father part Creek). He grew
up among Native Americans from many local tribes,
poor people who made poor white people seem rich. A
joke he knew: *How can you tell if an Indian is rich?* Pause.
He's holding a beer.

From a young age he was fascinated by Indian
mythology. He liked the idea that the world came into
being through a story, on the back of a turtle maybe, or
on the breath of the Great Spirit. He liked that wish
and will and dream were no less "real" than the material

world, which was crooked and confused. In fact, it was the material world—this wretched earth of trailer parks and liquor stores and heat-baked flat-land—that would vanish as if never here, while our dreams could go on forever, making and remaking the world, inventing time, conjuring existence.

In the '70s, he explained his childhood to the hippies and delinquents and ex-cons who came to Thunder Mountain, as it was locally known, like this: His father left when he was twelve. His mother married a new man. His stepfather wasn't a good man or a bad man; he was just a man. But a man is like a lion. When a cub grows up, that cub threatens the pride. Frank—just little Frank then, not the powerful Chief Rolling Mountain Thunder—was a threat to his stepfather's home. I imagine: Fisticuffs. Shouting. Broken things. Frank had to leave. So he left. He was a castaway (his word), an unwanted child, and I think his whole life afterward, right up to the day he died on a filthy, old couch inside of the living monument he spent two decades making, unfurled from this fact.

His childhood: He must have drifted around central Oklahoma as a boy, slept at friends' homes, camped. Maybe he tried to track down his birth father. He worked as a laborer and learned the basics of carpentry and concrete work. There was alcohol, lots of alcohol, sure there was, but he didn't like to talk about that once he was the Chief, except to point to a statue he made of himself, bent forward, hands on knees, thin as a rake,

face aimed at the ground in defeat, and say that was him in the bad time, when he weighed 120 pounds. Beyond that, he would say only that he, like many young people, was lost, duped by a culture of lies. He had no spiritual grounding as a young man. The white man's society, its coarse values and endless taking, had ripped it away from him. *Ha yay ha yay ha yay ha yay*, went his chant.

Later, in the '60s, when he decided he was the Chief, his children from his first two marriages, who knew him as Frank, thought he was depressed, had early senility maybe, needed help he'd never get, couldn't afford anyway. But he knew his problem had to do with his relationship with the Great Spirit. Making his monument was the way to fix this, to get right with the real power of the universe.

3.

Something else he didn't talk about as an old man: the Great War. He was in the army, saw combat in Europe, was almost "blown to bits by a German bazooka." His oldest son, Dan, has said that the war completely changed him. He was a decorated veteran. But if you asked him about it, he'd say there was nothing to talk about. All bad. Why bring it up?

He did sometimes talk about his life as a white man, as Frank Van Zant. He was once a cop, a sheriff's deputy. A good one actually. He worked for a time as a ranger. After that, he was a private investigator. He also trained as a Methodist pastor.

He had eleven children total—six, I believe, as Frank Van Zant; five as Chief Rolling Mountain Thunder, though it is possible he had more. He once said he thought of himself foremost as a father. When he became Chief in the mid-1960s, he still talked about

the kids he had as a white man, a cop, an investigator, an almost-pastor. "None of them smoked or drank," he would repeat. This made him very proud.

40

So: In 1968, he and his young wife have a vehicle breakdown on I-80. They're stuck. He wants to leave but can't. They become squatters in the foothills of the mountains, and this is the first time that the authorities take notice of them. "They don't much like Indians," he once said of the region. And, he said, they definitely didn't like an old Indian with a very young white wife, a girl who looked as if she could have almost been his granddaughter.

He fixes the truck. As he is trying, again, to leave the region, his truck, again, breaks down. Steams there on the side of the road under a glacier-blue sky, grains of wind-thrown sand pelting his skin, getting stuck in his hair. Old white man comes along in another truck. He's the owner of a five-acre plot of land along I-80, where they happen to be broken down, truck still hot and ticking. After some back-and-forth—"Did you

check the current in your starter?" "Battery okay?"—the landowner offers Chief Rolling Mountain Thunder the flat scrubland, surrounded by mountain peaks, along the interstate. He wants $500 for the five acres. He'll take $25 a month. Since the Chief can't seem to leave— he later said that the Great Spirit was keeping him there—he shakes hands with the landowner. Thirty-six bucks in his pocket. Minus $25. He has $11 left.

Within days of the handshake, he starts the Monument. Because he needs a place to live. He becomes the owner, from a capitalist perspective, of some of the worst real estate in the country. It also happens to be sacred.

5.

When you have no money, when you don't really believe in the white man's money anymore, you learn to see value in thrown-away things, scraps. He said it was funny that the white man had tricked himself and everyone else into believing that some printed paper was worth x amount because he said it was, funny that if people simply stopped *believing in* money, it would, that day, lose all its worth. Insanity, he thought—government-sanctioned, collectively bought craziness. Who needed it? Hell with the American government, which he used to be a part of in the army and as a sheriff. To hell with them!

He and his young wife had a camp trailer, normal size, about six feet by nine feet. He built up rocks around it, because there is no shortage of small and large boulders in northern Nevada, and then he covered it in his special mixture of concrete, which was cement, water,

and handfuls of sand, a concoction meant to achieve a thickness when sculpting and make material go farther and last longer.

From there, he built rock and concrete rooms off of the trailer, opening the trailer sides into hallways. He used colored bottles set lengthwise in the walls to allow in beautiful desert light, which was like laser beams at the start and end of each day. A few car windshields served as picture windows. Then he built up—first a second story over the trailer, more rocks, bottles, and concrete, then a tiny third story and a lookout. Like many outsider artists, he had no plan beyond a vision in his mind of what something might look like when finished. At the top of the structure, he created cement arches that crisscrossed in intricate patterns, each painted a different color—white, red, yellow—depending on what paint he could find at the nearby dump. He said the arches were there so the great eagle could swoop down from the mountain and into this valley and pick up the Monument when the apocalypse came.

He was a talented sculptor, certainly a skilled craftsman, though he laughed at words like "artist." He just made things, he said. He did it because he had to for survival, and once you're surviving, once you have a home for yourself and your family, you want it to look nice, especially if it is right beside an interstate, the American bloodstream, where everyone can see it. "I take nothing," he once said, "and make more nothing from nothing. I'm not trying to make a statement, you know. It's just what I have to do." He was the artist of nothing. When big trucks roared by on their way to Winnemucca or Carson City, they honked.

His first sculpture was of a son from a previous marriage who committed suicide at the age of nineteen, a deeply traumatic event in the Chief's life, one he could not talk about without crying even decades after it happened. His second sculpture was a large, highly

realistic self-portrait, a little bigger than life-size, set on the highest part of the Monument. He presented himself as a great Indian chief, arms raised, a lightning bolt held over his head like a spear. "When I first came here," he said, "I made me up there, me and a lightning bolt. See, they don't like old Indians around here, and they definitely don't like people with no money. So that's my way of saying that if you mess with me, you get the lightning bolt."

By the mid-1970s, there were sculptures dotting the landscape—on top of buildings, set into the rock and concrete walls, built into arches, standing alone or in clusters in the scrub brush, built off of scraggly, high-desert trees, on the hoods or roofs or trunks of abandoned cars. He usually did Indian faces and heads or naked women, the latter based on his third wife.

He said when he sculpted, he was simply releasing the face that already existed inside of the material. He used a small trowel and his hands. When you see pictures of the Monument of Chief Rolling Mountain Thunder in its heyday, all those sculptures, you have to marvel at that fact: his hands and a small trowel. It's like being told the Lincoln Memorial was made by a guy with a claw hammer and some sandpaper.

7.

In the mid-1970s, he became a human-interest story locally and regionally. People marveled at how he and his many itinerant guests salvaged boards and metal from abandoned warehouses, how they used bent guardrails for building support, old cars for berms and foundational material, or how they trucked in loads and loads and loads of rocks from the canyons and mountains.

He and his third wife had five children in Imlay, all with the last name Rolling Mountain Thunder. And for a while, he had something akin to a commune on his property, including a hostel full of people "in trouble." Some of the people were young—runaways, half-recovering drug addicts. But as the years wore on, into the late '70s and early '80s, it was mostly old people on the property, sick or on a pension, poor and without a home: outcasts. He believed in helping the meek, the lost. He hated the idea of people waking up on the street

to a big cop over them with a club. He once claimed he served thirty-four thousand meals in one year to the needy, though he had absolutely no money. How did he do it? He compared it to the miracle of Jesus and the five loaves and two fish that is mentioned in each of the four Gospels of the Bible. This is one of the many stories he told that is not true. But I like it.

8.

I'm watching a documentary made by Allie Light and Irving Saraf titled, simply, *The Monument of Chief Rolling Mountain Thunder*. You can watch it as streaming video at Folkstreams.net, a resource on folk and American roots culture. The film is twenty-eight minutes long and was made in 1983, a very bad year in the Chief's life, but in the interviews on film—I'm pausing, rewinding, replaying—he comes across as lucid, calm, articulate, and philosophical. He is heavyset, with an olive complexion and black moles on his face, shoulder-length black hair with gray streaks in it, and a bushy gray beard. He smokes one cigarette after another, smoke streaming from his mouth as he talks as if this is a normal bodily function.

As I said, he thought of himself mainly as a father. And what is clear from the film, more than anything else, is his emotional devotion to the five children he

was raising with his wife. Toddlers and babies crawl on his lap, listen to his gentle stories, kiss him. Older kids sit beside him, deferential. They range from maybe six months to around ten. They trust him completely, and it seems a genuine trust, one that is born of gentleness and parental love. But the children are filthy, probably undernourished, regularly in danger among all the debris and trash on the property. They grow food and forage and play in the wind-whipped sand with an old shopping cart with squeaking wheels. They have a pet goat whose milk they drink. They play on a playground Chief made for them of rusty truck wheels, splintered boards, and bed springs.

And there were other dangers. Teenagers from the nearby towns vandalized the place in the night. Men stopped on the side of the highway and shouted at his young wife behind a fence of three ropes of barbed wire (by the late '80s, he had barricaded off the property with dead cars, bed frames, fencing, lawn chairs, and anything else he could find). The police were always on the lookout for problems—not *for* the family but *from* the family, a highly suspicious bunch of commune hippies. Social services wondered about the health of the children and wanted to interview them. Once, so the Chief said, two men tried to kidnap his wife. They threw her out of the car along the highway after she fought. The police wouldn't help or press any charges. That's another of the stories he liked to tell. I have no idea if it's true.

9.

In 1983, the year the film was made, a film that presents the domestic situation as unusual by the standards of the culture but also stable and loving, Chief Rolling Mountain Thunder was named Artist of the Year by the state of Nevada. But he was becoming angry and paranoid. The visitors were all gone by then. No runaways. No ex-cons. No recovering addicts. No old and infirm. No loaves and fish miracles. He brooded. He had a temper. Then he was remorseful. This was the pattern. No more waving at the interstate traffic; now drivers got the bird, the middle-finger salute: *Fuck you, America, you fucking bully!* Soon after the making of the film, his wife left with the five children, quite possibly because the conditions were no longer safe or survivable, or because of his seemingly unappeasable anger, or both. Then an outbuilding on the property, once a hostel for guests, burned to the ground in a possible arson.

His anxiety increased. Antigovernment signs, painted onto refrigerator doors and old plywood, were placed along I-80. One referred to the fact that he was deemed officially disabled in 1968, not long after he stopped calling himself Frank and turned into Chief Rolling Mountain Thunder, and he still hadn't received a social security check by 1986. The police, he claimed, were menacing him, and they wouldn't help stop the teenage vandals from destroying his artworks, defacing his sculptures. He experimented for a while with trying to live underground, using rusty car exhaust pipes to let in breathable air, but the dry Nevada earth caved in around him.

In 1989, his health failing from virtually nonstop smoking since he was an adolescent, and with no money or health insurance to get care to alleviate his increasing physical and psychological suffering, he wrote his oldest son, Dan, a note, made himself comfortable on his worn-out couch in his main rock-walled room, and shot himself in the head. Thunder Mountain is now a Nevada historic site.

We Are Made in the Image of the Image We Made
(from a commonplace book)

1.

Imperfection is in some sort essential to all that
we know of life. It is the sign of the life in a mortal
body, that is to say, of a state of progress and
change. Nothing that lives is, or can be, rigidly
perfect; part of it is decaying, part nascent. The
foxglove blossom,—a third part bud, a third part
past, a third part in full bloom,—is a type of the life
of this world. And in all things that live there are
certain irregularities and deficiencies which are not
only signs of life, but sources of beauty. No human
face is exactly the same in its lines on each side, no
leaf perfect in its lobes, no branch in its symmetry.
All admit irregularity as they imply change; and
to banish imperfection is to destroy expression, to
check exertion, to paralyze vitality. All things are
literally better, lovelier, and more beloved for the
imperfections which have been divinely appointed,

that the law of human life may be Effort, and the
law of human judgment, Mercy. —John Ruskin

2.

As in more familiar exercises in close reading,
one can start anywhere in a culture's repertoire of
forms and end up anywhere else. One can stay, as
I have here, within a single, more or less bounded
form, and circle steadily within it. One can move
between forms in search of broader unities or
informing contrasts. One can even compare forms
from different cultures to define their character in
reciprocal relief. But whatever the level at which
one operates, and however intricately, the guiding
principle is the same: societies, like lives, contain
their own interpretations. One has only to learn
how to gain access to them. —Clifford Geertz

3.

Nothing is so conditional, let us say *circumscribed*,
as our feeling for the beautiful. Anyone who tried
to divorce it from man's pleasure in man would at
once find the ground give way beneath him. The
"beautiful in itself" is not even a concept, merely a
phrase. In the beautiful, man sets up himself as the
standard of perfection; in select cases he worships
himself in it. A species *cannot* do otherwise than
affirm itself alone in this manner. Its *deepest*
instinct, that of self-preservation and self-

aggrandizement, is still visible in such sublimated forms. Man believes that the world itself is filled with beauty—he *forgets* that it is he who has created it. He alone has bestowed beauty upon the world—alas! only a very human, all too human beauty . . . Man really mirrors himself in things, that which gives him back his own reflection . . .

—Friedrich Nietzsche

4.

But now that so much is changing, isn't it time for us to change? Couldn't we try to gradually develop and slowly take upon ourselves, little by little, our part in the great task of love? We have been spared all its trouble, and that is why it has slipped in among our distractions, as a piece of real lace will sometimes fall into a child's toy-box and please him and no longer please him, and finally it lies there among the broken and dismembered toys, more wretched than any of them. We have been spoiled by superficial pleasures like all dilettantes, and are looked upon as masters. But what if we despised our successes? What if we started from the very outset to learn the task of love, which has always been done for us? What if we went ahead and became beginners, now that much is changing?

—Rainer Maria Rilke

5.

Creativity is not the finding of a thing, but the making something out of it after it is found.

—James Russell Lowell

6.

A guilty conscience needs to confess. A work of art is a confession. —Albert Camus

7.

All art is autobiographical. The pearl is the oyster's autobiography. —Federico Fellini

8.

An artist is a dreamer consenting to dream of the actual world. —George Santayana

9.

I am a lie that always speaks the truth.

—Jean Cocteau

10.

Art for art's sake is a philosophy of the well-fed.

—Yu Cao

11.

In the information age, you don't teach philosophy as they did after feudalism. You perform it. If Aristotle were alive today, he'd have a talk show.

—Timothy Leary

12.

Whatever creativity is, it is in part a solution to a problem. —Brian Aldiss

13.

No one has ever written or painted, sculpted, modeled, built, invented, except to get out of hell.

—Antonin Artaud

14.

The creative process is a cocktail of instinct, skill, culture and a highly creative feverishness. It is not like a drug; it is a particular state when everything happens very quickly, a mixture of consciousness and unconsciousness, of fear and pleasure; it's a little like making love, the physical act of love.

—Francis Bacon

15.

I must create a system or be enslaved by another
man's. I will not reason and compare; my business
is to create. —William Blake

16.

Conditions for creativity are to be puzzled; to
concentrate; to accept conflict and tension; to be
born every day; to feel a sense of self.
 —Erich Fromm

17.

Art comes from everywhere. It's your response to
your surroundings. —Damien Hirst

18.

The true work of art is born from the Artist: a
mysterious, enigmatic, and mystical creation. It
detaches itself from him, it acquires an autonomous
life, becomes a personality, an independent subject,
animated with a spiritual breath, the living subject
of a real existence of being. —Wassily Kandinsky

19.

When I understand how my story is not just my
own but belongs to a larger one, I can feel a distinct
bodily pleasure. It is like being held, sustained by
perception. —Susan Griffin

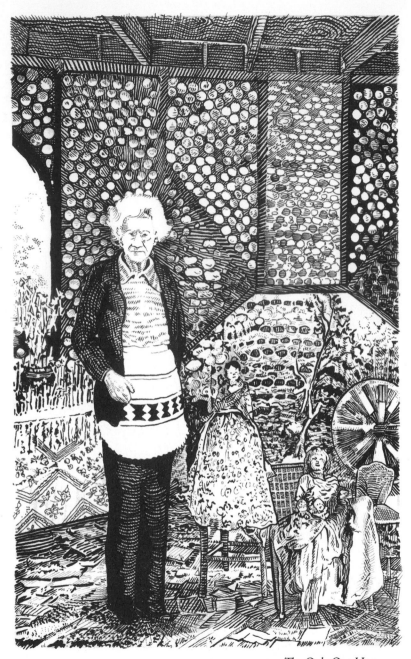

The Only One Here
A Portrait of Tressa "Grandma" Prisbrey

10.

Here comes Tressa "Grandma" Prisbrey, wearing her sun hat like a floppy sombrero. She looks tired. She sighs, a habit. This is her third or fourth or fifth tour of the day. Twenty-five cents a person, babies free.

She can't always remember things. Not clearly, anyway. She often says this to visitors to her famous Bottle Village in Simi Valley, California, a sun-scorched one-third of an acre along a two-lane highway forty miles northwest of Los Angeles. This is in the working-class suburbs, in the late 1970s. She is in her mid-eighties, a small woman with short, thick gray hair and bifocals. She usually wears a peach or yellow or red cotton shirt, matching pants, and blue or white or brown canvas sneakers, all from the clearance section at the nearby discount store or, sometimes, a neighborhood yard sale.

I made this here building, she begins, halfway opening the splintered, hinge-creaking door to one of her thirteen

bottle and concrete huts to show a family, a mother and two boys. But then Prisbrey's mind blanks. When was it? When did she make this?

It's all a blur sometimes now that she's older, that her health is failing—this life, the endless making, people coming and going, time. Some days she has no idea how she made all this, none at all, only that she did it, one small step at a time. She got herself a "notion." That's how she thinks of it. She went with it, went with the notion, which was both her and not only her. A woman once came by and told her it was God who helped, who gave her the strength for such an undertaking, and maybe it was God—why not?—but she doesn't like to spend too much time with that sort of thinking. You can get depressed dwelling on things like God and the past and your life. She looks ahead, moves forward. She has work to do, tours to give.

The mother stands back, smiles, waits, out of respect, for Prisbrey to finish her thought.

The two boys, ten and twelve, Southern California kids with deep tans and hair like dried straw, peer through the slice of open doorway into the building.

After a lost moment of staring at the hot, barren ground, Prisbrey says, a hint of upper Midwest still in her voice: *It's terrible I can't remember things. I'm an old woman now. [Laughs]. By God the world is good if you don't weaken, if you can stay strong, but it's hard to stay strong, don't you know. By God. I eat chicken for breakfast if I want to. My sister Hattie says you ought not eat chicken*

for breakfast, but I can't see why not if you like chicken. What difference does it make? I made my first building to keep my pencils. I had seventeen thousand pencils. That was a hobby, you know. I started that back in North Dakota, around Minot, when I was involved in politics. That must have been fifty years ago. I'd collect pencils— ones with pictures, bright-colored ones. Next thing you know I had thousands. One time I counted the bottles I have here, young man. I took two days to do that. I walked around and counted, for two whole days. In this hot sun, too! Guess how many? One million and fifteen. That's how many bottles I got! That's a lot, isn't it? Some are broken now, but that's how many I had, anyway. Well, go on in, look around, boys. She swings the door fully open, and sunlight sweeps right to left across the dark dirt floor of the building, the boys' shadows like long, alien life-forms stretching blackly through the room.

The boys, the flesh-and-blood boys standing beside Prisbrey in the bright day, look at her, then back at their mother, who nods. They duck their heads and follow their shadows into a different world.

2.

She was born Thresie Luella Schafer in 1896 in Easton, Minnesota. Her parents were Catherine and Matthew. She was the youngest of eight children in a destitute family. She slept hungry in a bed of bodies. In 1908, in hopes of finding work and at the edge of survival, the family followed Tressa's father to a homestead near Minot, North Dakota. At fifteen, in 1912, she married Theodore Grinolds, who was fifty-two years old and, according to one article I've read, of "poor character." According to another article, he was the ex-fiancé of one of her older sisters.

She thought girls were lucky. She said this sometimes. They didn't have the power of men to make decisions—sure, that was true—but if they were pretty, as she was, they could, sometimes with only a look, promise their bodies to a man who might be able to protect them and provide for them. She did not love Theodore—that

seems certain—but her life went from almost constant lack and suffering to something like stability, food on the table, a roof over her head that no one was going to take away.

With Theo, as he was called, she had seven children in the next thirteen years, before she was twenty-nine: Earl (1913), Raymond (1914), Frank (1916), Velma (1918), Othea (1920), Florence (1925), and Hubert (1926). I wonder if she had a miscarriage between 1920 and 1925, given this pattern of births. If Theo wanted her, he had her, so by the time her body healed from the last birth, she was pregnant again.

None of this was unusual. It was called marriage.

3.

Here is something interesting (though not surprising)
I keep running into while writing these portraits—
competing, or at least not agreeing, versions of the
events of these outsider artists' lives. Prisbrey, in one
version of her biography, gets fed up with the sinister
and selfish and maybe brutal Theo and takes her
seven children and leaves, with no money or hope, but
somehow manages—a story of fortitude and survival.
In another version, Theo dies in 1931—he would have
been around seventy, beyond the life expectancy back
then in the United States—and she takes what money
she has (enough for food for a week? a ride?) and goes
into Minot and works as a waitress and part-time singer,
taking care of all seven children by herself—also a story
of fortitude and survival, but a less dramatic one. I'm
more inclined to believe the latter, but it's quite possible
that neither version is precisely true, that many other

elements were at play that I'll never know about, never find in research. I've also seen her birth date listed, in different places in these articles on my desk, as 1896 and 1897, so even that basic fact is in question. Don't believe everything you read.

40

In the late '30s—Theo long gone one way or the other, that we know—she moves with her children to the Pacific Northwest, to Oregon, where there are more restaurants, where there is more waitress work. Then she moves to Washington and works for a time at Boeing. The kids grow up, move on and into their own lives, their own marriages. For a while, Tressa is involved with a man who trades horses and makes a good living. He gets sick; it turns serious; he dies. She meets another man, a richer man, but he dies in Europe while traveling before she can marry him. One of these men was a fiancé, but I don't know which one. Anyway, bad luck all around. And she liked these men much better than she ever did her husband.

Alone, she moves to Simi Valley, then called Santa Susana. It's 1946. She is fifty years old, and she lives in a small trailer on her sister Hattie's property. Hattie

is married to a man named Hanson of some means (there was of course a massive postwar building boom in Los Angeles, a spreading of prosperity). Hattie lives a middle-class life. The sisters have always been close, writing letters to each other throughout the years. Both are happy with the situation. They've sorely missed one another. During the time they've been apart: World I, the Great Depression, World War II.

My Lord, the world has changed! Prisbrey often says. *Soon they'll be flying around in spaceships!*

Southern California, in the late '40s and '50s, feels a little like Eden, or maybe just the far edge of the world. She's happier here. She's still poor. But this beats the hell out of Minot and the waterlogged Northwest.

5.

She meets Al Prisbrey, probably while she is working
as a crate packer for the Tapo Citrus Company. They
marry in 1947. She tells her sister that he is her first, her
only, true love. Al and Tressa buy a small plot of land on
Alamo Street and live on it in their trailer. Tressa makes,
for the first time, a concrete building. She needs it to
house her seventeen thousand pencils, most of which
she has glued in intricate patterns onto found cardboard,
wood, ceramic, anything that has struck her as a usable
frame. She uses cement and the cheapest concrete blocks
for the structure. It's a basic shed. Al helps her so she
will get the pencils out of the trailer. He knows if he
threw them away, they would get divorced. She doesn't
complain about his drinking, the bottles everywhere;
he doesn't complain about this quirk she has with the
pencils. It is an unspoken agreement. This is also called
marriage.

1

She begins what will later be called Bottle Village in 1956, when she is almost sixty, after she and Al sell the Alamo Street property and finance another small plot of land in Simi Valley, on Cochran Street, which is cheap because it is beside a loud and foul-smelling turkey farm. Tressa has moved around so much, has had so many lives by the time she is sixty, that—legend has it—she takes the wheels off of the trailer when Al is gone one day and hides them. "What happened to the wheels, Tressa?" he asks. "They're gone," she says.

Al drinks, as I've said. Mostly beer. Tressa wants to make a wall between her property and the noise of the turkey farm. But they have no money. Blocks—the simple cinder block or brick from the building supply place in town—are expensive. So she buys some cement mix, hooks up the hose, and uses beer bottles as the bricks for her wall. She likes how the light strikes the

brown or green glass, throwing the California sunshine around. She's onto something. She stares at the wall during certain times of the day, when the sun is just right, and she thinks about Velma, her daughter, who died the year before of cancer at the age of thirty-six. She feels that force, a notion, accruing inside her. Time works differently when she is working. Making is pleasure. Her art is joy held still.

7.

A person needs a hobby. That's how Al puts it. Between 1956 and 1961, Prisbrey creates thirteen different buildings on the site.

She starts by digging a foundation. Sometimes Al helps, sometimes not. She uses cement and bottles from the dump, where she goes every morning in her old Studebaker pickup to scavenge for materials (though she does not have a license). She dumps the bottles into a large pile near where the building will be. There is never a plan, never a drawing, never even much thought given to what the building will be or what it will look like. That notion. She just *starts*.

She pours cement in the foundation trench, then carefully places bottles in colored patterns in a row in the wet concrete. When the row is done, she starts another row: pour, arrange bottles, repeat. She uses other materials, too, including broken bricks, tiles, car

headlights, motorcycle gas tanks, and pieces of terracotta pots. It takes her several months to complete each building. Sometimes she will take a day off before starting the next structure, sometimes not.

Prisbrey "devoted herself to the task of expanding and maintaining the Bottle Village," wrote Roger Manley in his book *Self-Made Worlds*. "There were the Pencil House, Cleopatra's Bedroom, The Round House, the Rumpus Room, the School House, shrines and chapels, a Shell House, numerous other constructions, all imaginatively covered with detritus."

\mathcal{S}o

Detritus. This strikes me as a key word as I look through articles, notes, at photographs, as I watch YouTube videos and Folkstreams videos, as I Google Earth her street in Simi Valley.

She exhibits the traits of a classic hoarder, keeping bottles, bottle tops, filthy dolls, pencils, syringe tubes, hubcaps, television tubes, radio dials, citrus crates. She throws nothing away, for she has lived a life without, has been starved of possessions. She is driven to keep, to collect, to arrange as beautifully as she can, and her buildings and constructions—eventually seventeen of them—are part of her collections and also her places to store these collections. Over here, in this room: perfume bottles. That building over there: glass vases, hospital masks, lost keys. See these things, these American discards? Now multiply them by several hundred, a thousand, ten thousand.

9.

She always liked dolls, always wanted one as a girl, but she did not live a life as a child in which a doll could be purchased. She started to collect discarded ones in the late '50s. It became her biggest obsession when her loved ones began to die, most of whom were still in the Pacific Northwest.

In the mid- to late '60s a tsunami of death came her way. Florence died. Raymond died. Al died in a car accident, possibly drunk. Frank died. Earl died. All in the span of a few years.

She began searching for dolls every day at the dump while collecting bottles. She set up beds for the sick that were never used, were meant as memorials and testimonials and prayers. She made wishing wells, ecumenical religious shrines, good luck symbols. She wanted to charm and pray away her sorrow.

10.

I'm looking at a photograph of Prisbrey taken by Robert Pacheco, who captured, in the late '70s and early '80s, many evocative scenes from Bottle Village. I'm thinking about time, and memory, and how they work *phenomenologically*. In stillness, we remember. We inhabit the past, our memories, our losses; or we inhabit the future, our hopes, our dreams. But when we work, when we *create*, when we achieve *total concentration*, we exist only in the moment of that creation. Time stands still. Or she stands still as time rushes by, leaving her in peace. Pain from loss recedes, gets pushed out by the need for focus and problem solving. Prisbrey spends her days disappearing into the intense present of creation.

11.

She can no longer afford to live at Bottle Village by 1972. It's just her, without Al, and she lives a pauper's existence for years, existing off of money from tours. She moves to Oregon to be with one of her two last living children, Hubert. Hubert is ill, has cancer, and soon dies at the age of forty-eight. In 1974, with nowhere left to go, Prisbrey is allowed to move back to Bottle Village by the owner and be the property's "caretaker."

She continues to build and work, but now she focuses on what I find to be the most intriguing feature of Bottle Village, the walkway that runs between and around all the buildings and shrines. She pours concrete and into the wet concrete arranges objects found at the local dump, including scissors, pistols, bullets, plaques, picture frames, baby toys, skeleton keys, broken gardening tools, and other materials, all of it a kind of history of America in trash.

12.

She's surprised when art scholars start coming by. Outsider art? Folk art? What would those words possibly mean to her?

But she appreciates the attention and the money from the tours, which is enough now to live on and more. Her sister Hattie says she's a famous artist. And she begins to see herself as an artist, or at least a creator, someone who transformed the sorrow she felt in her hard life into this playful, whimsical place. You can fret and worry and dwell or you can get on with it, go forward, and do something. She sees Bottle Village as one of the local attractions, like Disney. "Anyone can do anything with a million dollars," she says. "But it takes more than money to make something out of nothing, and look at the fun I have doing it!"

In the late '70s, pieces of Bottle Village are part of five different traveling folk art exhibitions in the United

States and Europe. In 1979, the city of Simi Valley and Ventura County both make Bottle Village a historic landmark.

13.

Also in the '70s, Prisbrey has a series of small strokes, from which she never fully recovers, though she continues to work for a time. By 1982, she becomes too sick and weak to live by herself. She moves to San Francisco to live with her last living child, Othea. As her health continues to deteriorate, she is placed in a nursing home, where she will die in her sleep in 1988 at the age of ninety-two.

In the nursing home, she is popular among the patients and nurses for her colorful stories and her ragtime songs. One of their favorite stories is the one about how a woman in a business suit, her hair perfectly done, came to Bottle Village once and asked Prisbrey if she was the crazy old woman who spent all her time making these strange buildings out of junk and collecting every useless piece of trash under the sun. "Well," says Prisbrey—and the patients and nurses wait silently in

this extended pause, though they've heard this one many times before—"I'm the only one here, ain't I?" The room erupts into laughter.

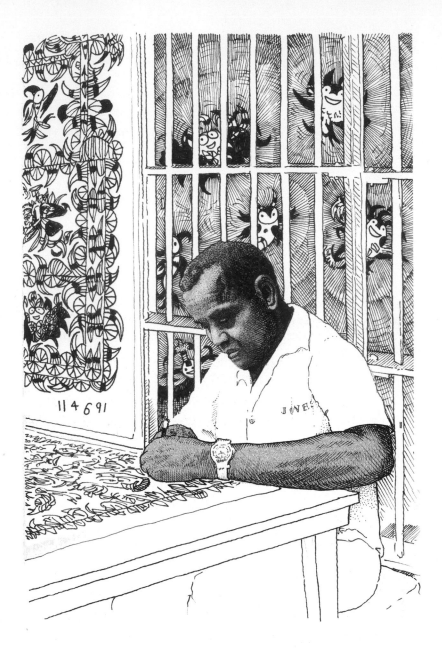

In the Devil House
A Portrait of Frank Jones

1.

Imagine: A summer day, a dirt road, heat thick as steam from a boiling pot. Along the shoulder are verdant trees, shadows, the hum and croak and whistle and buzz of the woods. This is Clarksville, Texas, 1910. And here is Frank Jones, who will one day, decades from now, years after his death, be among the most recognized African American self-taught artists.

He is nine years old today, a skinny boy walking quickly in front of a plume of his own kicked-up dust. He is heading for the cotton fields where he will work. He is always on time. He considers himself lucky to be seasonally employed by a local white farmer.

Frank gets these feelings sometimes, feelings he cannot put into words, feelings he would never talk about even if he could. They are like a cold breeze whispering up his spine, entering his mind, tickling on the inner curves of his skull. When they come he knows some force from

the spirit world is near, a hole is opening up. Ever since he can remember, his aunt, who has raised him, has told him he is special, born with a caul, a transparent flap of fetal membrane over his left eye. Everyone in his African American community knows this means he will be able to see into the spirit realm. He is gifted and cursed. He believes this is why his momma and daddy left him. They were afraid of the trouble his power could bring.

A sound from the woods, like his name on the wind. He looks, squints. Birdsong, a breeze. In the shadows, in the tree trunks, as his spine hums, as his skin prickles and the hairs stand up on the back of his neck, he sees the suggestion of his first apparitions, camouflaged but definitely there, a part of the natural scene rather than distinct from it, shape shifting in the play of speckled light, smiling and chattering, calling him toward their world.

Eyes wide, he takes off sprinting for the work fields— huffing, arms swinging—his kicked-up dust chasing him like a beige ghost.

2.

It began as a lark, his late-life drawing. In 1961, old Frank was just another black man among the mostly black and Hispanic men in Huntsville prison, or the "Walls Unit." The prison was the first built in Texas, in 1848, and it was the only prison in the South still functioning at the end of the Civil War, when violence and lawlessness were beyond control in the aftermath of four years of carnage and the slaughter of 650,000 Americans, including, by best counts, more than fifty thousand civilians. Frank was here on a rape charge after already having been in and out of Red River County Jail on rape, murder, and burglary convictions. He started collecting scrap paper from the guys who emptied administrators' wastebaskets. A guard offered him a couple of discarded red and blue pencils, once used for bookkeeping. "Go on and draw them devils you always talkin' 'bout, Frank," said the guard. "I reckon I might," said Frank.

I imagine Jones, sweating in the South Texas heat, a throbbing fear in his chest, put the crumpled, off-white paper up against the wall of his small, concrete cell. Using the pencil nubs, he started by making horizontal and vertical lines, creating symmetrical boxes, like a child's game of tic-tac-toe, which he thought of as rooms in his "devil house." The lines were then decorated with elaborate barbed-wire-like spikes or claws. Inside each room—each cell—was a smiling demon with horns and wings, sometimes breathing fire. Some looked like happy cartoon birds. Others snarled. He gave form to the "haints"—a southern colloquialism for a spirit or lost soul—he had seen walking around in the world since he was nine.

He had no plan, no real artistic intent. That's not how this works. This kind of art—visionary art—is more like a ball of fire stuck in the body that finally bursts forth out of the mouth and eyes. He represented, as best he could and with the materials at hand, the spirits who had tormented him, drawn him in, tricked him. During the last eight years of his life, after he had spent nearly a quarter century in Texas jails and prisons, and before he died of cirrhosis of the liver in 1969 at age seventy, Jones exorcised his demons by drawing them, by taking them out of his confused mind and jailing them on paper. They had menaced him throughout his miserable existence. They had made him do such shameful things. For the first time in his life—as a poor black man in the South, as most likely a paranoid schizophrenic, as a

man who may not have been guilty of some or all of the crimes for which he was convicted (we'll never know)— he held some small power over his circumstances. His aunt had told him he would be powerful. But he had felt so weak throughout his life, so at the mercy of his demons and the laws and codes of a white man's world. His cell was within walking distance, if you could make the steel and concrete vanish, of the infamous Texas execution chamber, and every time the state took a man's life another haint was born. Inmates suffered, then died, then they came back to make others suffer. A circle of suffering. Only Frank could see it. His curse. He kept drawing.

3.

He was born in 1900 to Edward Jones and Sarah Clark. Like all blacks in Clarksville, Texas, he descended from slaves who had been brought west from other parts of the South as free labor in the fields (though I've read that he also had some Cherokee ancestry). His father left first. His mother then left him with his aunt when he was a baby. This was not uncommon and often necessary for survival. Throughout slavery, infants were taken away when their mothers were sent back to work, sometimes never seeing each other again. Husbands and wives were separated. So were brothers and sisters. The old who could teach the young disappeared, the young then cut off from their history, their genealogy, any sturdy sense of community or identity. An African American child might ask this common question: *Who am I?* The institution of slavery—a crime against humanity as big as any—answered: *You are who I say you are and nothing*

more; you are a commodity, a working machine or a burden to your society, a thing made to aid in the life of a white man or woman. And later, after slavery (Abraham Lincoln was kept off the presidential ballot and thus received, even with the potential for write-in, zero votes in Texas in 1860), in the South and the larger United States, blacks were seen as less than fully human, unworthy of an education or a trade, unable, most often, to achieve any modicum of economic security or accumulate wealth or property to pass on from generation to generation, assuming societal realities hadn't already dismantled or destroyed the family (which they most often had). Just as whites had taken the land from Native Americans, a white Texan of means and connections could easily have a family of blacks removed from a fertile field or sloping hillside with a paper that said it was fully legal for him to do so. White police officers could lynch blacks suspected of crimes without these deaths being seen as murder, or even unjustified. Killing a black man in East Texas in the early twentieth century was barely more extreme than killing a dog that kept bothering the livestock. As a boy, Frank understood, from the stories and songs he heard in the fields, from his aunt's teachings, that the law was used as a weapon against black people. The real story of America has always been the one about power and privilege—who has it, who doesn't. Whites could only trespass on whites. Blacks were always trespassing. Every step Frank took was a trespass. His family and community had been granted freedom from slavery,

but *only* freedom, which was like being rescued from a sinking raft to be stuck on a bare, cold rock in the middle of the ocean. How would your mind hold up?

40

As a child, he would have lived in a shack, I assume, probably with many other people related to him or to each other. He never went to school, never learned to read or write or tell time by the clock, though he understood, better than you or I, the cycles of the sun, the seasons, the weather. And he was touched. Everyone said so. They talked about it all the time. He had no choice but to believe it.

Frantz Fanon ends *The Wretched of the Earth* with a series of "case studies" about the ways in which racially and ethnically oppressed people go mad within an incoherent social system that defines them unceasingly as other, stigmatized, lesser, and inherently criminal. R. D. Laing, in the '60s, suggested severe mental illness was not an unreasonable response to the distortions and abnormalities of our world. Jean Dubuffet, in the "raw expression" of art brut, later termed outsider art by Roger

Cardinal in 1972, saw a kind of *psychological resistance* to this distorted world—a redistorting, if you will, through art, of largely unquestioned and dehumanizing social and cultural situations.

No one ever forgot about Frank's power, his curse, or the day he was born with the strange translucent bubble over one of his eyes. The people present at the birth knew that he was a newborn seeing them in this world with one eye and still seeing the spirits in the next world with the other eye.

5.

A haint can be housed in anything, living or not. A
white woman on the street looks at Frank and she has
the face of a bird of prey. A man's hat speaks to him with
a gator's mouth. Trees whisper. Porch lights are the eyes
of demons. A stop sign in the wind dances a centuries-
old curse. Birds squawk hidden messages from an
underworld. He could not take it, this magical life. It
was torture.

So he drank. When he was out of jail or prison, that
is. He finally drank himself to death, which was not easy
considering the last third of his life was spent mostly
behind bars and forcibly sober. But when he drank, he
drank with gusto, drank for oblivion—rotgut, moonshine,
anything, even poison, that had alcohol in it. He drank like
a man who believed the haints could not live in a booze-
soaked mind. He was drowning them. But as soon as he
stopped drinking, they came back. So he drank some more.

6.

Drunk, he prowled the night. He went mad with the visions and voices, but then came back to quieter thoughts and emotions and found work. Madness, or magic—whatever you want to call it—was cyclical, or maybe pendulum-like, coming and going, coming and going. There was *yessir this* and *yessir that* for months at a time in the sultry fields during his teens, twenties, and thirties. He loaded munitions onto trucks for a few months before World War II. He married three times, each marriage less stable than the last. The government had secret messages for him. The devil could spread himself along the ground like morning dew.

His first arrest was for the rape of a seven-year-old girl in 1941. The facts seem to be: He had taken her in—or the house he lived in with other poor blacks had taken the girl in—when she was abandoned as a baby. Her mother came back to claim her. Frank wouldn't let

her go. The mother went to the police, said her girl was like Frank's slave. Frank died swearing he was innocent of this crime. He never touched the girl that way, he said, which may have been true. The police said there was no doubt. He spent eight years in prison.

He got out, prowled the night again, drank toward suicide. His last marriage was to Audrey Culberson, who had two grown sons. One of Frank's stepsons murdered an elderly woman in Clarksville during a robbery. Frank was implicated in the planning of the crime. He said he didn't do it, but he was a drunk on a porch slurring his swears. He went back to jail for nine years.

Free for only two years after this sentence, he was accused of another rape, this time of a woman late at night in Clarksville. He again swore he was innocent, had never touched her, but he had no alibi and he was always out at night, drinking or looking for a drink, hearing voices, watching the devils as they disguised themselves as people, trees, machinery. He had a record, was known by the cops (many of whom were proud members of the KKK not only in Texas but throughout the South), and was in the area. At that point, he was a walking suspect. It didn't matter what the crime was— he was a suspect. And as he would later admit, the haints were always trying to get him to do evil things. And he couldn't always remember his nights. Time vanished and he didn't know where it might have gone. He entered the maximum security prison in Huntsville in 1960.

7.

He was a docile old man in Huntsville. In photographs, he looks like Scatman Crothers in Stanley Kubrick's *The Shining*. Some thought he was a little "retarded," screwed up in the head, damaged. Like a child really. A few didn't think he'd ever raped or robbed or had anything to do with killing anybody. Just didn't seem to have it in him. His drawings—"this here is a haint house, y'all"—were something of a joke among the guards and inmates. They all looked the same and he did more than five hundred of them! He couldn't read or write so he signed them with his prison number: 114591. He drew and drew and drew, like a cloistered monk praying, putting his mind and fears on the page over and over and over. If he didn't have his pencils, he'd be fidgety, beside himself, pacing. *Haunted*.

8o

In July of 1964, when "rehabilitation" was a new word bandied about in penal policy, the Texas Department of Corrections held its first art show. A guard entered Frank's drawings as a prank but later said he did it to make him "feel good." The work was judged by art faculty from nearby Sam Houston State, all of whom were aware of Jean Dubuffett's idea of "art brut" and the "raw expression" of the mentally ill and socially marginalized. This was the '60s. A new appreciation for Duchamp's "readymades"—a urinal as a work of art; Allan Kaprow's "happenings"—spontaneous performance art events in public spaces; minimalism. Anti-art—art that sought to destroy the oppressive, quasi-authoritative idea of fine art—was in the air. Needless to say, Frank won the show. Shortly after this, a collector and business manager named Murray Smither, of the Atelier Chapman Kelley gallery in Dallas, which is owned by the talented painter

Chapman Kelley, began to visit Jones. Smither brought larger and better paper and finer blue and red pencils. He also began to purchase and deal many of the most complex and accomplished drawings. Frank used the money to buy a gold watch. He couldn't tell time, but he loved the look of a man in a fine gold watch.

In October of 1964, Atelier Chapman Kelley held a solo show of Jones's work, which was the first visionary art exhibit to be held in Texas. It was covered by local and regional papers and Jones's art began to be much more widely known. The story that he believed demons and devils followed him increased his notoriety, that he was a prisoner in one of the meanest institutions in the country, in the execution capital of the world, did even more for what we might call his "cultural capital."

In the following years, throughout the 1960s and early '70s, Jones's drawings were exhibited in galleries and museums in Texas, Virginia, North Carolina, and Kansas. "You're a famous artist, Frank," said the guard. "I reckon I am," said Frank. His aunt had always told him he was special. Maybe he was after all. He loved his gold watch.

9.

Smither and Kelley became friends with Jones, benefactors and social workers of sorts. They worked to get him paroled for years, the first several attempts denied. Finally, in late 1968, Jones was set to be released to live in Dallas and continue his drawings in a quiet studio. But Frank had spent too much of his life fighting demons with alcohol. I bet he never regretted his drinking; I bet he thought booze was one of the best things this cold world had to offer. In February of 1969, the week he was to become a free man, he died of liver disease in the infirmary of Huntsville prison. His drawings now sell for thousands of dollars each. In March of 1969, his corpse was shipped back to Clarksville for burial. He had earned little more as a visual artist in his lifetime than it took to cover the funeral expenses. What was left of his estate—the

accumulating value of his drawings—was turned into a scholarship fund for Clarksville art students from underprivileged backgrounds.

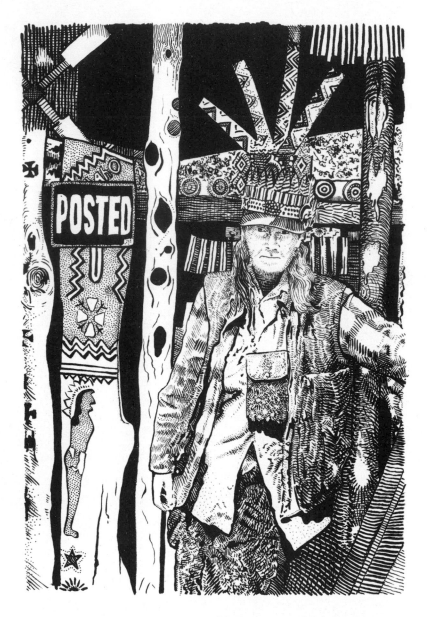

The Importance of Good Company
A Portrait of James Harold Jennings

1.

At the end, in April of 1999, James Harold Jennings was still good to the stray cats. They'd been around, keeping him company—how long? He couldn't say. The cats had come and gone and come again over the twenty-five years since his mother died in 1974. There were calicos and browns and blacks, cats with green eyes and brown eyes and yellow eyes that flashed red in the night. There were mommas and babies and old tomcats, ten or twelve at any one time, skulking near his seven broken-down buses out on Perch Road in Pinnacle, North Carolina, where he lived without plumbing or electricity. The cats walked around his painted wooden sculptures, his leaning silver-painted shacks, the sawhorses and piles of sawdust, the rusted old saws, the shiny new saws, chisels, boring tools, hand sanders, cans of paint, paintbrushes, rain-filled five-gallon buckets, rags, mixing sticks from the hardware store in King.

He let the strays eat the crusts from his ham sandwiches. He let them drink the foam from his cans of Miller beer. He let them have the dregs from the bottom of a cold can of generic pinto beans—two for $1 at the Panda grocery down the road.

Those last days it was just James and the cats. They saw him as he walked around the property, which had been in his family since before his birth in 1931. He still carried brushes and pencils and pens in his multiple leather belts and pouches, which he slung around his hard, thin body, over his shoulders, and he had his portable radio hanging around his neck, bouncing on his bony chest as he stepped over refuse, boards, discarded art materials. For years, he had listened mostly to country music, but now, agitated, fairly humming, he tuned in only to AM fire-and-brimstone preachers and right-wing talk shows and news of the impending collapse of everything at the coming millennium—computers blinking to sleep because of something about zeros, financial crashes, runs on banks, no travel possible except on foot or bike or horse because the gas would run out, no phones or other communication, violence in the streets, starvation, chaos, maybe even tanks right here on these rolling hills in Stokes County, in the once great Confederate state of North Carolina.

He kept his revolver in a holster on his hip. But he never pointed his gun at a cat. He pointed it only at shadows and noises and his own thoughts racing around in his head. He loved those cats.

2.

James Harold Jennings's father was a blacksmith and veterinarian. He died in 1934, when James was three. Veterinarians, back then, and in that part of the country, were often simply people—sometimes licensed, sometimes not—with the skills needed to stitch up farm dogs, birth calves and pigs, tell you when one sick rooster might infect your whole coop, set a horse's or mule's foot or leg to see if the owner could keep from shooting it, which was, finally, an economic issue.

And back then, of course, you could get yourself properly deceased with, say, gingivitis, or appendicitis, or a mean dose of bronchitis on a damp night, or tetanus from farm fencing, or the pooling internal bleeding from a wrong-set broken bone, the whole limb getting a little green, then purple, then here comes a fever, *but oh you'll probably be all right* just before they find you room-temp in the morning. For most of our short American history,

people have been dropping dead with profound ease, no more permanent than summer mud puddles or brittle fall leaves.

James couldn't remember his real dad.

3.

James's mother was a schoolteacher, loving toward James by all accounts. We should remember, though, that "loving" back then, and in that part of the country (my own family is from the piedmont of North Carolina), might mean it was your parental duty to beat a child severely about the back and rear and legs with a good whiplike switch for wetting the bed or some other unavoidable small-person infraction. But she took care of him and his brother through the depression, keeping up, as best she could, and with what help she had, their small tobacco farm. Later, tarried by the daily tasks of farming, she rented the fields to tenant farmers. Eventually she married a man from King—a town magistrate she probably met at church, the main social event of the week—and she then rented out the farmhouse and her fields.

The family moved to King, which was the big city to

James, though it had a population of only a few thousand. It had an official public school (not just a schoolhouse) full of town kids, a movie house, streets filled with cars. James was ten.

40

School wasn't his thing. He was such a nervous kid, like a scared cat in his way, ready to run heart-hammering fast away from danger, and when other kids, big kids, with their booming voices and laughing and confidence, came streaming down school hallways, he felt a little wave of panic, just a touch, move through him like a slug of Novocain. He didn't do well—socially or academically. Not a bad kid, but just "a mess," as people in North Carolina like to say. Finally, his mother let him quit school when he was twelve, which was not so unusual in those days, and she homeschooled him at the house in King, taught him what he needed to know.

Though organized education wasn't for him, he was an avid reader throughout his life, and as a teenager, homebound by his moods and ingrained fear of life, he read *Popular Mechanics* and *National Geographic*

and how-to books and journals, along with all that his mother assigned him—science, history, novels.

He made his own radios and little engines and gadgets, one after the other, always doodling with something, which gave him purpose, kept him focused. Without that, his mind might have gone into overdrive, thoughts just pinging off the walls.

When not working on little machines, he liked to read dictionaries, flip through and learn new words, the meaning of things. At some point as a young man, though he was a supporter of the Republican Party and a Protestant Christian to the end (like almost all his neighbors), he became interested in books on the occult and magic—astral projection, metempsychosis, the idea of harnessing all the raw energy of the universe. In 1986, after his work started to be known in southern outsider art circles, he told Steven Litt of *The Raleigh News & Observer* that what truth there was in the Bible was in astrology, though what he meant by that was never made clear. He said: "You can get down on your knees and pray for what you want, and if it comes, it comes, but it won't be from God."

5.

He continued to live with his family through his thirties, had to really, but he had jobs. He was known around town as an oddball maybe, "Red Jennings" with the freckles and red ponytail, but he came from a good, loving home and he wasn't dangerous or a bother to anyone. Decent fella. A loner, was all. Every small town in America has a few.

If you were driving north out of Winston-Salem and sailed through the main drag of King, past the shops and grocery and hardware, you might have thought him a homeless guy, and you wouldn't have been able to tell that he had probably read a lot more books than you had, or that he could take your refrigerator apart and put it back together again, or maybe just take it apart and use the parts for a wholly different machine that he could quickly design—something with wings.

He worked for a time picking tobacco, which was filthy, hard work and not for him. Then he got a job at a lumberyard as a night watchman, which was better and which gave him his days for sleeping and working on projects and reading up on Indians and history and religion.

In the late '60s, he worked as a projectionist at the local cinema. He understood machines, little whirring electrical engines, so he fed film and fixed problems like a master in a room above the theatre. No one bothered him. It was his kingdom behind a heavy door that smelled of metal and oil.

He started drinking whisky daily, then mixing it with huge amounts of caffeine so he didn't fall asleep in the projection room, then, oh, say doubling or tripling the whisky for good measure, then quadrupling the stimulants.

He liked machines, and his body, after all, was a lot like one, so he got to where he was testing its capacity for extremes. How much could one take of depressants and stimulants at the same time before the engine went kaput? How fast could a heart beat? How many thoughts could a mind have at one time before these tangled thoughts shot out on a beam of light through the theatre air and crashed into the screen?

He had a nervous breakdown in his late thirties—a series of what we'd now call panic attacks related to depression and anxiety. It scared him. He didn't want to be crazy. He didn't want to get stuck in that kind of misery. He quit whisky and stimulants. He quit work. He quit driving. He bathed less than frequently. He started riding a bike around town, wearing the same dirty pants and flannels and T-shirts and old stocking or brimmed caps. He sometimes collected cans, took them to the redemption center for a little pocket money, enough to get a moon pie or a six-pack of Miller. He still lived with his mother and stepfather, but one would imagine relationships might have been getting a little frayed. If you know small towns in North Carolina, then you know the neighbors were talking.

But after a breakdown, you're buzzing and life is twice as hard as it was before. Hard to look into a person's

eyes. Hard to be seen. Hard to speak. That thing that's come up that you need to do, that you usually think of as a simple thing—how hard, how impossible, is that going to be? Jesus!

You spend time alone. You have to. You try not to think so much as you think so much about trying not to think so much. You're a prisoner and your own prison guard.

7.

A year after his breakdown, James's stepfather died. He and his mother left King and went back to Pinnacle, to the farmhouse. In 1973, his mother, with whom he had had a very close relationship all his life, went into an elderly care facility. He once said she had taught him all he needed to know. A year later, when James was forty-three, she died, leaving her two sons the farmhouse, land, and enough inheritance for James not to have to work to support his near-pauper's lifestyle, which he called "living kind of low, like the Amish."

James lived by himself in the farmhouse, which had no indoor plumbing, electricity, or telephone. He rose with the sun and retired with the dusk. He believed in the logic and cycles of nature. If you were in tune with them, they taught you how to live and behave; you live like an animal, which, of course, is what you are.

He later began to call himself the "Artist of the Sun, the Moon, and the Stars."

8o

Grief, isolation, and loneliness, it seems, sparked the art, as it has for so many outsider artists.

He began to construct a series of interconnected small shacks not far from the house, which he painted silver, which may have had something to do with his interest in astrology and the occult. He used scrap wood to begin his first "whirligigs"—wind-powered constructions that ranged from windmills to Ferris wheel–like structures as big as a man to wood cutouts of brightly painted animals such as turtles and snakes. At first, he used paint discarded by homeowners and returned to the hardware store, often with the color labels torn off or paint-smudged, so there was no color coordination or "palette" selection beyond what was cheap and available.

In the mid-1970s, the artist Randy Sewell, having driven by and seen the ever-growing art presentation, began to purchase some of these pieces from Jennings,

who did not at first see himself as an artist at all. More like an inventor with a lot of time on his hands, someone *Popular Mechanics* might write about. But he liked the attention. And the money allowed him to choose the paint he wanted, buy some better tools (though nothing electric), and have more cheap brushes around. He refined the look of his work. He could afford a six-pack of Miller every day and have his favorite lunch: A "Miller sandwich," two Millers with one in between.

$\mathcal{9}_{\circ}$

In 1985, as word about Jennings got around the communities of collectors in the South and Mid-Atlantic, the important outsider art scholar, historian, and curator Tom Patterson chose several of Jennings's pieces to be included in the show *Southern Visionary Folk Artists*, which opened in nearby Winston-Salem and included works by the better-known Howard Finster and Sam Doyle.

By then, Jennings's art had found its cartoonish style, and he was making his bright, person-size, multipiece, quasi-mechanical figures painted in his distinctive sky blue, with other bold primary colors vying for attention. He was perhaps most famous for his series of "Amazon" women beating up men who seem to have tried to take advantage of them. In one of his finer works, *The Devil Gits Sat On*, a powerful woman, not unlike an image of his youthful mother, has the devil's head in a professional

wrestling leg lock. The background is his choice blue, as usual, with two intricate, vaguely American Indian circular designs, each made of smaller circles in orange, white, green, yellow, red, and lighter blue, framing the proceedings. Above the Amazon's left shoulder is a white cat looking out at the viewer.

Like almost every outsider artist you could name, he obsessively reconfigured a finite series of images and motifs from his immediate outer and inner worlds. And like almost every outsider artist you could name, he did not "evolve" much technically or aesthetically. He found a way to express what he needed, psychologically, to express. Then he did it over and over and over again. Outsider artists don't often get "better," in the way we might define that in academia or curatorial culture; they get *more*.

10.

By the late '80s, Jennings had abandoned the farmhouse completely and moved into a lot down the hill, which was bordered on one side by the road, two sides by woods, and one side by one of his rented-out tobacco fields. He now lived in what was, at least for a time, one of the most famous outsider art environments in the South.

He eventually accumulated seven run-down church and school buses. He lined them up around the perimeter, the way pioneers circled wagons to protect their camps. None of the buses was legal to drive or driven. In front and around them were elaborate and numerous wooden cutouts of figures and animals, small and large whirligigs, and other hard-to-define contraptions. All of which were inspired by his individual brand of religion, which mixed Protestantism of the South with New Age notions about astrology, goddesses, and even shamanistic conceptions of time and reality.

He continued to wake at sunrise and retire into one of the buses at dusk to sleep, stopping work during the day only to eat, have a few Miller beers, and feed and pet the crowd of stray cats.

11.

In hindsight, it is easy to see that toward the end, in the late '90s, he was suffering from deep depression and paranoia about the coming millennium. He accepted fewer visitors, was suspicious of those who came. His mind and emotional life had always been partly broken, and he spent almost all his final time listening to right-wing radio and the apocalyptic news of our coming destruction. He didn't—couldn't—assess the way media and fearmongering commentary work as an unavoidable part of American culture, as you might. Hate, anger, truth-bending, open lies, the worst interpretation of a set of facts repeated over and over to destroy the credibility of a foe—they are now just another strain in the mega info-overload pop culture of our times. We are all shaped by this reality, this set of morbid symptoms, of course, but he was a fragile soul, like a child really, a person who could never function as a "normal" citizen

of our society. He believed every awful word, day after bad-news day.

On April 20, 1999, his sixty-eighth birthday, he shot himself in the head, scattering the crowd of cats into the woods and under the buses. This was the same day Dylan Klebold and Eric Harris took automatic weapons and homemade bombs into a high school in Colorado and murdered twelve fellow students and a teacher and then finally killed themselves in the library. Though these incidents may seem unrelated, I can't help but notice they both have a particularly American brand of fear, fatalism, and nihilism at their heart. We're good at producing many things here in the United States, including bombs, monsters, distorted thinking, nonsense, and some very confused, desperate people. As William Carlos Williams famously wrote, "The pure products of America go crazy."

Jennings, crushed by psychological and cultural incoherence, spent his life as a hermit seeking coherence though his obsessive making. When the process stopped working, he had no choice but to die. He might have told you in those last days that he was as good as dead already.

12.

The poet Jonathan Williams tells this story in his obituary for Jennings that ran in *The Independent* of London on May 3, 1999: He was visiting Jennings in Pinnacle in the mid-1980s. Two collectors from Michigan showed up to look around the buses and grounds, to inquire about purchasing some art. Jennings was always polite to visitors back then. He let them poke around as if he were a store owner.

One of the collectors asked Jennings why he painted, why he worked so hard and made so many assemblages and sculptures, enough to fill a large warehouse.

Jennings, filthy and paint covered, looked at them, tightened his ponytail, thought for a moment, then smiled and said: "Well, boys, you know there's a whole lot of company in what I do. I never ever get lonely . . . That's because my art is something they call visionary art."

Only in Human Terms
(from a commonplace book)

1.

I would say that our patients never really despair
because of any suffering in itself! Instead, their
despair stems in each instance from a doubt as to
whether suffering is meaningful. Man is ready and
willing to shoulder any suffering as soon and as
long as he can see a meaning in it. —Viktor Frankl

2.

I can negate everything of that part of me that lives
on vague nostalgias, except this desire for unity, this
longing to solve, this need for clarity and cohesion.
I can refute everything in this world surrounding
me that offends or enraptures me, except this chaos,
this sovereign chance and this divine equivalence
which springs from anarchy. I don't know whether
this world has meaning that transcends it. But I
know that I do not know that meaning and that it

is impossible for me just now to know it. What can a meaning outside my condition mean to me? I can understand only in human terms. —Albert Camus

3.

To grasp life and meaning, we assume constancy where it does not exist. We name experiences, emotions, and subjective states and assume that what is named is as enduring as its name. Human beings blessed and cursed with consciousness— especially consciousness of their own being—think in terms of names, words, symbols.

—James F. T. Bugental

4.

Terrorism and the whole drug scene are vivid examples of the fact that what persons abhor most of all in life is the possibility that they will not matter. —Rollo May

5.

Like great works, deep feelings always mean more than they are conscious of saying. —Albert Camus

6.

This is what is sad when one contemplates human life, that so many live out their lives in quiet lostness. —Søren Kierkegaard

7.

Madness need not be all breakdown. It may also be breakthrough. It is potential liberation and renewal as well as enslavement and existential death.

—R. D. Laing

8.

The rightful claim to dissent is an existential right of the individual.

—Friedrich Durrenmatt

9.

Man finds nothing so intolerable as to be in a state of complete rest, without passions, without occupation, without diversion, without effort. Then he feels his nullity, loneliness, inadequacy, dependence, helplessness, emptiness.

—Blaise Pascal

10.

In order for the artist to have a world to express he must first be situated in this world, oppressed or oppressing, resigned or rebellious, a man among men.

—Simone de Beauvoir

11.

God creates out of nothing, wonderful, you say:
Yes, to be sure, but he does what is still more
wonderful: He makes saints out of sinners.

—Søren Kierkegaard

12.

This work is an attempt to understand the time I
live in. —Albert Camus

13.

Art would not be important if life were not
important, and life *is* important. —James Baldwin

ACKNOWLEDGMENTS

Sections from this book first appeared in *Creative Nonfiction*, *Guernica: A Magazine of Art & Politics*, *Killing the Buddha*, and *Utne*. The essay on James Hampton was made into a radio documentary, with music from the Blind Boys of Alabama, by the program *Soundprint*, on Radio New Zealand. Special thanks to W. David Powell for his illustrations.

ABOUT THE AUTHOR

Greg Bottoms is the author of three collections of essays and stories and the highly acclaimed books *Angelhead* and *The Colorful Apocalypse: Journeys in Outsider Art*. He is a creative writing professor at the University of Vermont.